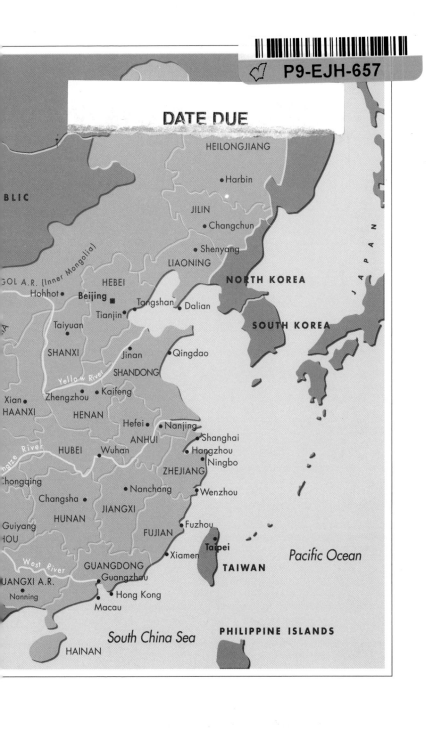

HEILONGJIANG

•Harbin

JILIN

•Changchun

•Shenyang

LIAONING

NORTH KOREA

SOUTH KOREA

BLIC

GOL A.R. (Inner Mongolia)

Hohhot•

HEBEI

Beijing ■

•Tangshan •Dalian

Tianjin•

Taiyuan•

SHANXI

Jinan• •Qingdao

SHANDONG

Yellow River

Xian• Zhengzhou• •Kaifeng

HAANXI

HENAN

Hefei• •Nanjing

ANHUI •Shanghai

River HUBEI Wuhan• •Hangzhou

•Ningbo

ZHEJIANG

Chongqing •Nanchang •Wenzhou

Changsha•

HUNAN JIANGXI

•Fuzhou

Guiyang

FUJIAN

HOU •Xiamen Taipei

West River •Taipei

GUANGDONG TAIWAN

UANGXI A.R. •Guangzhou

Nanning •Hong Kong

Macau

HAINAN

JAPAN

Pacific Ocean

PHILIPPINE ISLANDS

South China Sea

Arts of the Tang Court

Series Editors, China Titles:
NIGEL CAMERON, SYLVIA FRASER-LU

Arts of the Tang Court

PATRICIA EICHENBAUM KARETZKY

HONG KONG
OXFORD UNIVERSITY PRESS
OXFORD NEW YORK
1996

ess

k Bogota
a Cape Town
ng Kong Istanbul
Madrid Melbourne
Singapore
Taipei Tokyo Toronto

and associated companies in
Berlin Ibadan

Oxford is a trade mark of Oxford University Press

First published 1996
This impression (lowest digit)
1 3 5 7 9 10 8 6 4 2

Published in the United States
by Oxford University Press, New York

British Library Cataloguing in Publication Data
available

Library of Congress Cataloging-in-Publication Data

Karetzky, Patricia Eichenbaum, 1947–
Arts of the Tang court / Patricia Eichenbaum Karetzky.
p. cm. — (Images of Asia)
Includes bibliographical references and index.
ISBN 0-19-587731-4 (hardcover : alk. paper)
1. Art, Chinese — T'ang-Five dynasties, 618-960. I. Title. II. Series.
N7343.3. K36 1996
709'.51'09021—dc20 96-25889
CIP

Printed in Hong Kong
Published by Oxford University Press (China) Ltd
18/F Warwick House, Taikoo Place, 979 King's Road,
Quarry Bay, Hong Kong

Contents

Acknowledgements

For my husband, Monore Karetzky, who
made it all possible

Sincere thanks are due to the following individuals who provided invaluable assistance during the course of this research: Duan Wen-jie, Director, Dunhuang Research Institute, Dunhuang; Wang Shi-ping, Curator, Shaanxi Province Historical Museum, Xi'an; Zhou Yue, Vice-President for Education, Shaanxi Province Historical Museum, Xi'an; Zhang Fang, Chief Curator, Shaanxi Provincial Museum, Xi'an; Han Jin-ke, Museum Chief, Famen Temple, Xi'an; Liu Ding of the Shaanxi Provincial Famen Museum, Xi'an; and Yang Ziu-sha of the Sichuan Provincial Museum, Chengdu.

More general thanks are due the staffs of the Shanghai Museum of Art, Shanghai; the Zhaoling Museum, Xi'an; the Xinjiang Uygur Autonomous Region Museum, Ürümqi; and the Gansu Provincial Museum, Lanzhou; as well as to Patrick Coleman, Chief Librarian, the Library of the Metropolitan Museum of Art, New York.

PEK
Fort Lee, NJ

Introduction

THE TANG DYNASTY, which spanned nearly three hundred years from AD 618 to 907, gives its name to one of China's most illustrious epochs, known for its extraordinary artistic accomplishments in the fields of literature, painting, calligraphy, sculpture, ceramics, and Buddhist art. During this period great advances were made in the sciences, medicine, and technology. The first pharmacopoeia, *Old, New, Tried, and Tested Prescriptions*, was compiled by Zhen Chuan in 643. Woodblock printing and gunpowder were invented, and polychrome porcelain was perfected.

These accomplishments were made possible as a result of the stability and prosperity brought by a strong central government. Following four centuries of political chaos and humiliation by barbarian regimes, China was once again united under a native dynasty. The military power mustered to unite the kingdom was maintained, so that the boundaries of the empire continued to expand and China enjoyed its greatest period of territorial growth. At their furthest reach the country's borders extended westward into Central Asia, east to Korea, and as far south as Champa, a kingdom in what is now Vietnam. With the empire's domination of large parts of Central Asia, trade routes—including the overland system known as the Silk Road—were secure, and commerce flooded the country's heartland. Its large and cosmopolitan cities were centres for international business.

During this time of imperial affluence the arts flourished. Like earlier empire builders—King Asoka of India and Alexander the Great before them—the Tang emperors were sponsors of massive building projects and patrons of the arts. Some of these rulers, renowned for their art collections

1

and connoisseurship, were themselves artists: the second Tang emperor, Taizong (r. 627–49), was a poet and calligrapher; the great Xuanzong (r. 712–56), known as Ming Huang, the Enlightened Emperor, was a calligrapher and musician. As divine rulers of the largest realm in the world, the members of the royal family surrounded themselves with pomp and splendour. Art objects and furniture filled their palaces. Alongside portraits of members of the family, the palace walls held murals that illustrated Confucian themes by using the examples of famous emperors and heroes of the past. The imperial art collection grew continuously through tribute and imperial request.

For the relatively new fashions of drinking grape wine and tea, cups and utensils of precious metals, jade, and ceramics were made. Experimentation with various techniques for the manufacture, glazing, and firing of pottery led to the invention of porcelain. Some of these ceramic vessels are characterized by austere simplicity and refinement in shape, while others are ornately decorated. Following the opulent style of the Persian court, the Chinese made use of gold and silver plates, bowls, and cups utilizing a complex and variable number of techniques with delicately inlaid, engraved, or three-dimensional decoration. In recent years, a new appreciation of these arts has developed with each discovery of a previously hidden archaeological site.

Enjoying the patronage of the court, the visual arts proliferated. Tang painting is characterized by a new interest in naturalism. Perhaps stimulated by Western art, transmitted from India through Central Asia, the artists of the Tang strove for realistic portrayals of their subjects. Their skills in portraiture were directed to an appreciation for finely articulated figures, with each presenting a striking contrast of race, age, and status, and with a true portrait quality achieved not only in the creation of each figure's individual

appearance but also his or her character and state of mind. Similar aesthetic goals are seen in paintings of horses, for which the Tang is justly celebrated. Horses are grouped together so that each contrasts with another's anatomy, pose, and even facial expression, conveying the special character, valour, and strength of the individual.

Religious art and landscape painting shared these goals of naturalistic representation. Although images of the Buddha are less often subject to stylistic transitions, his image being treated relatively conservatively throughout the period, the drapery of his clothes is realistically depicted, the anatomy of his figure is clearly defined, and the idealization of his divine wisdom and benevolence takes on concrete expression. The attendant figures, treated with greater liberty, become individual portraits of a variety of spiritual creatures and human disciples. Similarly, as landscape painting for the first time came to the fore as a primary subject, the vocabulary of landscape forms increased and the scenery began to achieve a measure of autonomy from the restriction of figural action.

In treatments of all the subjects of painting a new approach to brushwork is evident. Whereas in earlier eras the 'iron wire' brush, with no variation in the weight of the line, was used to describe the forms, Tang art used a brush that thickens, thins, and turns in space, engendering the line with aesthetic qualities. Such awareness of the expressive possibilities of the brush is the result of developments in the art of calligraphy. Beginning with the emperor Taizong's interest in court calligraphy, the art of writing was given a great deal of attention. Officials directed to write court edicts and pronouncements considered the manner of writing an expression of the authority of the Tang. The authors of the Tang writing style looked back to the work of the best calligraphers in the past to create a classic style that reflected

the glory and stability of the dynasty. Their concerns were for balance in the form of the elements of the characters, dynamism in the writing of the strokes, and legibility. The confident and virile style that they created was used throughout the empire and became known as the classic Tang court style.

We know something of the practices of Tang court painters from several histories of art written late in the dynasty. Zhang Yanyuan compiled his *Lidai Minghuaji* (Record of famous painters) in 847, and Zhu Qingxuan composed *Tang Chao Minghualu* (Celebrated painters of the Tang) in the same decade. Late Tang art was recorded by Guo Ruoxu in *Tuhua Jianwenzhi* (Experiences in painting), written in the eleventh century. Visiting the capital after the destruction of Buddhist monuments in 845, Duan Zhengshi wrote the *Sidaji* (A vacation glimpse of the Tang temples of Chang'an).

For most of the dynasty, Daoism and Confucianism were considered the twin pillars of the state, and as such they enjoyed imperial support. Buddhism, however, imported from India as early as the Han dynasty (206 BC–AD 222), had by the time of the Tang become the country's major religion. Dozens of sects proselytized their teachings in thousands of temples, and hundreds of thousands of monks worshipped the Buddha. Buddhism spread throughout the country, enjoying lavish aristocratic patronage and widespread public support.

The main Tang capital, Chang'an, near the present-day city of Xi'an in Shaanxi province, had a population of nearly two million residents. A second capital, also a thriving metropolis, was Luoyang, in modern Henan province. When the Central Asian trade routes began to be compromised by Arab invasions in the eighth century, the sea routes linking China to India became more viable and Yangzhou, in modern Zhejiang province, became an important

commercial centre. These large, walled cities had originally been founded during the Sui dynasty (AD 581–618) and were laid out in a grid-like pattern of intersecting streets and broad avenues.

Each part of the city of Chang'an had a special function: in the northern sector were the imperial residences, the administrative centres, and the Daming Palace. The palace comprised thirty buildings, including halls, towers, terraces, and rambling gardens with large artificial lakes and open pavilions; its three great state halls could accommodate thousands of the emperor's subjects. Aristocratic residences were in the southern sector, and the commercial markets were in the eastern and western wards. A canal system linked the districts. Outside the walled city were various Buddhist and Daoist temples and an Islamic mosque.

Until 845, when a xenophobic rage forced many non-Chinese out of the country, one hundred thousand foreigners lived in Chang'an, most drawn to the city to engage in mercantile traffic on the Silk Road. The foreigners built Islamic mosques, Zoroastrian temples, and Nestorian churches in the metropolitan areas. Foreign dignitaries were expected to take part in certain imperial ceremonies, notably weddings, funerals, and state rituals. Their presence brought foreign goods and entertainments into the city. International bazaars offered Roman and Near Eastern glass, Sassanian silver, Central Asian and Persian rugs, exotic silks and embroidery, musical instruments, pottery, and jewels. In the food markets all manner of spices, exotically prepared foods, and rare fruits were available. Entertainers from Central Asia, dancers, musicians, jugglers, acrobats, magicians, and storytellers performed for the court, while Central Asian singing girls filled the local bars, their strange airs the accompaniment to lyrics written by prominent poets such as the eighth-century Li Bai. There were even Western

artists at court, such as Wei-Chi Yi-Seng, a Central Asian who received high rank and imperial favour at the end of the seventh century.

The Tang Emperors

The founder of the Tang was a military official of the Sui dynasty, Li Yuan (r. 618–26), who ruled as the emperor Gaozu. At a time when political turmoil caused by floods, crop failures, and regional insurrections was widespread, Li, cautious and moderate, won confidence as a leader. Due to his brilliant military strategy and astute statesmanship, he and his faction emerged successful among the various rebellious groups. Li's most important victory was the conquest of the Sui capital of Chang'an, where even before the declaration of the new dynasty he had established a bureaucratic structure for legal and administrative functions that drew upon Confucian tradition. During his reign, he re-established the exam system for selecting scholar–officials and ordered historians to make records of the preceding dynasties as well as noting contemporary events.

The political institutions established during the reign of Gaozu were the foundation for the accomplishments of his son, the emperor Taizong. Since the Li family claimed to be descendants of the Daoist patriarch Laozi, Gaozu designated Daoism as the dominant religion. Throughout its reign, the Tang court maintained close relations with the Daoist church, which advised it in political as well as spiritual matters. Under Gaozu's reign, Buddhism, in contrast, was reduced to the status of a foreign religion.

Li Shimin, who ruled as the second Tang emperor, Taizong, excelled in the military arts. As a youth he was an intrepid leader who achieved many of the important military victories

that led to his father's attaining the throne. At the age of twenty-seven, perhaps through coercion, Shimin inherited power from his father. Continuing to lead military campaigns, he expanded the empire's borders, defeating the Turks in the north-west in 632 and taking Tibet in 641. He moved south into Annam in 648, and although an attempted conquest of Korea led to a Chinese defeat in 645, victory was eventually won by his successors.

Taizong was not only a military genius of swashbuckling valour and charismatic charm but an able administrator. Historians credit him with strengthening the foundations of the empire by establishing important bureaucratic institutions in the areas of military, court, and public administration. Important innovations were made in the handling of such matters as land redivision, the rate of tax and the method of its collection, the legal code, and the relief granary system for years of bad crops. Additional Confucian institutions were set up, including the Wenxueguan and Hungwenguan, colleges of Confucian scholars, and the emperor himself presided over the compilation of Confucian texts and commentaries. He is remembered for his poetry, calligraphy, and collection of art and antiquities. Taizong is considered an adept, if not original poet, who celebrated his own military exploits as well as noting weather conditions and landscapes.

The reign of the third Tang emperor, Gaozong (r. 649–83), was coloured by the influence of his extraordinary consort Wu Zetian. Ascending to a position of eminence through murder, extortion, and bribery, Wu became the emperor's closest advisor—so much so that they were called the Two Sages. When Gaozong became ill in 660, Wu Zetian took up the responsibilities of governance, and after his death in 683 she usurped the throne, declaring herself sole ruler of the new Zhou dynasty in 690. With intelligence, cunning,

and cruelty, Empress Wu (r. 684–705) played the various powerful factions against one another to win support over the entrenched aristocracy. She conspired against the imperial princes, deposing and executing those who hindered her direct control of the state.

Although her regime was characterized by unmitigated ambition and oppression, Empress Wu was an able administrator who enjoyed a long and relatively stable reign. She promoted bureaucrats over the established nobility, amplifying the role of the civil service, and engineered military victories in Korea and Tibet so that the Chinese empire reached its greatest size. With the expansion of the dominion, trade along the Silk Road flourished, enriching the coffers of the state. As a result of the spirit of internationalism dominating her reign, all of the arts were influenced by Western styles.

In contrast with preceding rulers, Empress Wu was wholly supportive of Buddhism. Many of the period's most important religious projects, including a number of the caves of Longmen, especially in the eastern hills, were created under her direction. Wu also supported Confucian institutions, performing the Feng Shan sacrifice at Mount Tai in celebration of the pacification of the empire, and undertaking the construction of the Ming Tang, a revered Confucian structure near Luoyang which functioned as a site for imperial sacrifices, year-opening ceremonies, announcements of the calendar's laws, and other state rituals.

These various projects required lavish expenditures of money and in 705, in opposition to the many abuses of Wu's reign, her wanton use of violence and secrecy, and her vast expenditures, a group of Tang loyalists led by the crown prince marched into the empress's bedroom and demanded her abdication and the reinstatement of the Tang

dynasty. Their choice for emperor, Zhongzong (r. 705–10), however, did not enjoy a long reign: within five years he met an untimely death. The short and relatively uneventful reign of Zhongzong is important largely because of the four imperial burials undertaken by him on behalf of the princely youths who were victims of Empress Wu. These four tombs, located near Xi'an, are furnished in imperial fashion with thousands of ceramic pieces, tomb furniture, and hundreds of metres of murals that are a rich source of information on Tang portraiture, architecture, and landscape painting.

The next great emperor of the dynasty, Xuanzong, known as Ming Huang, ruled at a time characterized by extraordinary achievements in the fields of art and literature. In the visual arts, highly naturalistic portraiture was realized in both figure and horse painting, and the polychrome glaze technique for porcelain production was perfected. Luxurious articles made of gold and silver were fashioned with the most intricate and delicate of decorations which called upon complex combinations of gold-making techniques.

During the first half of his reign Ming Huang was a model Confucian emperor, deeply concerned with affairs of state. In the middle of his reign, however, having accomplished much of his programme, Ming Huang lost interest in running the state and devoted his time to the harem. His affair with the concubine Yang Guifei came to overshadow all other matters. She so captivated him that he spent his energies pursuing leisure activities: playing polo, participating in concerts with her Pear Garden Orchestra, commissioning paintings, and collecting antiques. Their many revels lasted for days at a time. Yang Guifei's influence on the arts is pervasive: in her image the ideal of feminine beauty changed from the youthful, nubile, slim adolescent to the mature portly woman, swathed in gowns of thick brocade with transparent silk scarves. Her towering chignon,

studded with jewelled combs and large flowers, was dubbed 'cloud tresses'. Gradually Ming Huang became absorbed in the mystical practices and life-extending procedures of dark Daoism and esoteric Buddhism. His preoccupation with personal matters is often cited as the cause of the chaos that destroyed his reign and nearly ended the dynasty.

Although the military campaigns of the early part of Xuanzong's reign—against the Turks of Mongolia and Xinjiang in 727, and against the Tibetans in 733—were successful, the threats of the Arabs and Khitan on the north-western border remained grave. One of the emperor's generals, a Central Asian named An Lushan, was greatly successful in countering these attacks. His popularity at court was sponsored by Lady Yang, and his political power grew steadily. Perhaps discontented with his command, or having been slighted by the emperor, in 755 he led his troops into the capital at Luoyang and took the city. In 756 he entered Chang'an and proclaimed himself emperor of a new dynasty. With this rebellion the Tang experienced its first nadir in a series of political humiliations and military defeats by the forces they so long had held in check. The emperor and his consort fled to Sichuan. During the journey the imperial guards demanded that Yang Guifei be surrendered and they strangled her on the spot. The emperor's son, the heir apparent, fled north-west of the capital to organize a successful resistance to the rebels and proclaimed himself emperor in his father's absence, ascending the throne as the emperor Suzong (r. 756–62).

The latter half of the dynasty saw a procession of rulers, some of whom reigned for less than a year. Strong emperors, such as Daizong (r. 762–79), Dezong (r. 779–805), and Wenzong (r. 826–40), were successful in strengthening the empire and restoring Confucian institutions. Building up central authority, they were able to hold in check the

enemy forces on their borders and to limit the power of the eunuchs, who nevertheless became an increasingly powerful force in the government far exceeding their court duties. The greed of the eunuchs and their interference in state policy, coupled with the encroaching hostile forces on the borders of the empire, were a continual burden on the government. In the latter part of the ninth century, wars spread from the borderlands to central China, causing civil disorder and armed rebellion. With the destruction of central authority, the Tang dynasty ended in the first decade of the tenth century.

The Tang Tombs

Much of what we know of the Tang derives from discoveries made in tombs of the period. Tang imperial grandeur is most gloriously reflected in the style of its leaders' burial. Although none of the subterranean vaults housing the emperors themselves have been unearthed, the Tang *shendao*, or spirit way, with large sculptures aligned along a single avenue, set the standard for the remaining dynasties. The extant sculptures of these tomb paths mirror the grandeur associated with imperial rank.

Many artefacts have been recovered from Tang tombs and, with the murals painted on the chamber walls, have provided important information about the life of their times. One notable tomb complex is that of the second emperor, who had his tomb built into a mountain at Zhaoling, northwest of Xi'an, thereby achieving a more permanent structure. His high-ranking favourites were allowed the privilege of having their tombs built on avenues that radiated out from the central imperial site, creating a whole that itself resembled a great city.

Qianling, the mausoleum complex of Empress Wu and her husband, the emperor Gaozong, is another well-preserved site. Its one hundred or so free-standing monumental stone sculptures are exemplary of the organization of the funereal procession space. In the environs of Qianling are the tombs of the four imperial youths reinterred by order of Zhongzong. These tombs are generally similar in plan to earlier satellite tombs. An underground sloping path leads to a series of passageways equipped with side alcoves that housed hundreds of ceramic objects; these chambers alternate with shafts to provide sufficient air for the artisans working within. Next, on level ground, is an inner passageway leading to the front chamber in which a rich assortment of funeral articles was placed. A corridor connects this room with the rear coffin chamber. The murals that cover the walls of the tomb represent the many activities of the Tang aristocracy, as well as the daily activities of courtiers.

In the various genres of pictorial and calligraphic arts a courtly Tang ideal was created that has long been associated with military strength, prosperity, and cultural accomplishment. This Tang ideal still serves as a classical standard important to artists seeking to perpetuate the grand tradition. The Tang landscape style, its ideal of feminine court beauty, and the finest examples of its horse paintings were the inspiration for artists of later dynasties wanting to evoke the glory of the past. Similarly, the layout of the Tang tombs and the organization of the spirit way, as well as styles of both religious and secular architecture, became the classical models for succeeding generations.

1

Tang Painting

MOST of the Tang emperors called artists to court for architectural constructions, the planning of gardens, and, most importantly, painting. In their scrolls artists recorded strangely garbed foreign emissaries with their peculiar gifts of tribute, the exotic birds and wildlife of the royal parks, and the celebrated steeds that filled the imperial stables. Famous beauties and courtiers are shown in their favorite pastimes of horseback riding, playing polo, singing, dancing, and playing music or games of chance.

The second Tang emperor, Taizong, although perhaps better known for his military achievements than for his artistic ones, had a coterie of painters, architects, and artisans waiting upon his aesthetic needs. The renowned painter Yen Li-ben (600–74) accompanied the emperor on his pleasure excursions, painting on command the theme of paired mandarin ducks or a wild beast's attack on the imperial party at play. Yen himself is especially remembered as a portraitist, his subjects ranging from the emperor, to distinguished scholars and foreigners bringing tribute. 'The Emperors of the Past', in Boston's Museum of Fine Arts, one of the rare paintings with a Tang attribution, is ascribed to Yen.

Figure Painting

As recently discovered Tang tomb murals affirm, figural depictions dominated the art of the dynasty. Murals provide numerous examples of portraiture originating over several hundred years. Looking at this body of evidence,

an evolution of style can be seen in the artists' growing capacity to paint various types of people in a number of different circumstances. Unlike tomb murals from earlier periods, with their representations of agricultural activities, horse-herding, and banquets, Tang tombs are filled with images of the court's pastimes and amusements.

In paintings of the early period the figures are barely differentiated one from another. They stand stiffly, in a limited number of poses, proudly holding their offerings. Slender, contained, columnar forms, their bodies are restrained, rarely engaging the surrounding space. Over time, however, the figures grew more varied in physical appearance and pose and began eventually to interact with the space around them. Because all tombs have murals of beautiful female attendants, one can also trace the vagaries of fashion over the centuries. In the earliest examples, the feminine ideal is an adolescent slender beauty, by mid-period the archetype envisions a mature portly woman, and by the end of the dynasty the epitome of beauty is again considerably slimmer but still older and thicker-waisted than those of the opening era. Depictions of the styles of garments, hairdo, and make-up also vary with each period.

Major developments in painting technique occurred under the Tang. Primarily, one sees a new appreciation for the expressive possibilities of line. The unchanging 'iron wire' line of the past was replaced by a varied and more flexible form that shifts in width, dimension, and intensity. Thick dark lines were used for the contours of the figure, lighter, thinner lines rendered the interior definition of the drapery, and delicate lines were used for the facial features and decorative details. In colour, the Tang palette is generally harmonious, dominated by light reds and pale greens.

Early Tang-style murals appear in the tombs of the officials Yang Gonren (tomb dated to 640), Duan Jianbi (dated to

651), and Li Shuang (dated to 668)(Plate 1). All these murals share a generic approach to portraiture: an inflexible line, limited poses, and little exploration of the figure in space. The paintings, dating from 669, in the tomb of the famous general and minister Li Ji, however, show figures that are easily distinguished one from another. Slim and youthful, the maidens wear distinctive high-waisted garments with brocade cuffs, bodice, and hem; scarves are draped over their shoulders. In one fragment, two dancing girls swirl and dip: both their postures and the movement of their gowns and scarves suggest the whirling rhythms of dance (Plate 2). Their tresses are worked in a complex fashion to form arabesques that imitate flowers on either side of the head.

By the first decade of the eighth century, both the style of painting and mode of fashion had changed, as is seen in the court attendants depicted on the subterranean ramps of the paths leading into the funeral chambers of the imperial tombs of Zhaoling. In the murals of the tomb of Prince Li Xian, dated to 706, the young ladies wear deeply cut garments that reveal cleavage, a rather unusual occurrence in Chinese art. Their hair is naturally gathered on the top of the head, or at the back. There is no exaggerated hairdo of piled tresses. Moreover, for the first time the ladies are shown reacting to specific events. One, for example, protects her face against a gust of wind; another (Fig. 1.1), holding a large colourful cock, turns her head to rebuff the seemingly lewd comments of a male attendant. In contrast to her feminine grace, he is an unpleasant-looking character with a large bulbous nose, thick reddened lips, and buck teeth— he leans towards her leeringly. In another mural the artist presents a greater range of physical types: a portly elder woman with a high-piled chignon is accompanied by a young lady dressed as a Central Asian male and a dwarf

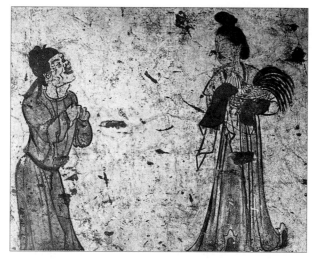

1.1 Female attendant with cock and onlooker, mural, tomb of Li Xian, Qianxian county, Xi'an, dated 706.

in court dress (Plate 3). Over time, Tang artists began to show a variety of characters, as well as their individual psychological reactions, through careful attention to the drawing of physiognomy, pose, and expression.

The murals at Zhaoling also portray aristocratic pastimes such as hunting, playing polo, and musical parties. Li Xian's tomb has painted on its east wall an elaborate hunting party with over fifty horsemen (Plate 4). Set in a landscape indicated by sparsely placed trees and large boulders, the hunters ride their mounts at full gallop. Exotic hunting animals ride with them: trained cheetahs are seated on silk tasselled pillows behind the saddles, falcons are held in gloved hands, and small hunting dogs are nestled in the riders' laps. These hunting animals, familiar in the West, especially Samarkand, were used by the nobility in China for only a brief period during the Tang.

Although there are no hunt scenes in the imperial tomb of Prince Li Zhongren, dated to 705, its murals present a series of Central Asian attendants holding such animals (Fig. 1.2), whether they be hawks perched in gloved hands or hunting hounds and cheetahs held on leashes. The grooms, who were often Westerners celebrated for their animal-training skills, are carefully delineated, with special attention paid to their non-Chinese features: large noses, 'round' eyes, thick eyebrows, and facial hair. They wear Central Asian-style dress with a wide-lapelled belted tunic, trousers, and tall boots.

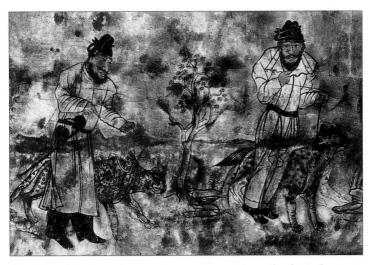

1.2 Central Asian trainers and animals, mural, tomb of Li Zhongren, Qianxian county, Xi'an, dated 705.

The earliest known representation in China of the sport of polo is also found in Li Xian's tomb. A Persian game, polo was first introduced in the early Tang as a military exercise, but by the middle of the period it had become an

aristocratic sport enjoyed by both men and women. Historical records describe the construction of large polo arenas and paintings of members of Xuanzong's court at play. Even sets of ceramic tomb figurines playing polo, such as those in the 692 tomb of Wei Jiong, have been found. In the mural in Li Xian's tomb, a hilly, sparsely treed landscape is the backdrop for the game. Five contestants are actively engaged, and the lead rider turns backwards in his saddle to hit the ball with his mallet (Plate 5). His horse rears as he takes his shot, while three other players close in.

Fashions changed by the middle of the eighth century, and women were shown as middle-aged, portly, and extravagantly garbed. Large, full-bodied figures are swathed in silken drapery, their voluminous tresses piled high in the 'cloud' style. Such images are said to be the result of the influence of Yang Guifei, the court favourite of emperor Ming Huang. Although little is left of the magnificent works of art commissioned by the aesthete emperor under whose aegis the greatest names of Chinese painting were active, recent archaeological evidence provides a pale reflection of its imperial glory.

A fragment of a painting found in Astana, near Turpan, dated to the Tianbao era (742–56) of Ming Huang's reign, shows the new image of corpulent and mature feminine beauty dressed in the height of fashion (Fig. 1.3). The intricate brocade patterns of her gown, jacket, and transparent shawl are painted in brilliant hues of orange and green. Her make-up emphasizes vibrant cherry cheeks, a foreign-style decorative tattoo between her eyes, and deep-red lips. Upswept in a voluminous topknot, her hair is held in place by delicate pins. Not portrayed as passive, as were ladies in earlier eras, she is playing a board-game: with her head bent in concentration, she earnestly moves the pieces with her left hand.

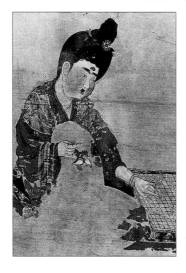

1.3 Lady playing a board-game, mural, tomb no. 215, Astana, Turpan, dated 715.

This style of rendering Tang court ladies—occupying the entire height of the composition against an empty background—is often referred to as the Monumental Figure style. Extant copies of silk handscrolls showing ladies playing sixes or making silk, attributed to Tang masters such as Zhou Fang, are preserved in both Chinese and Western museums and celebrate the mid-century ideal of court beauty.

Artists of the time were intrigued with the possibilities of representing all types of people. Tomb murals preserve a variety of portraits, including those of unattractive characters like the telling rendering of a middle-aged man found in Lady Xue's tomb, dated 710, in Dizhangwan, Xianyang, Shaanxi province. In this sketch-like portrait (Fig. 1.4), the servant's brow is furrowed, and deep wrinkles gather around his mouth. Similarly, the Hu, or barbarian, physiognomy and the rapt joy of performers are captured in the murals of Su Sixu's 745 tomb. Dancing with his

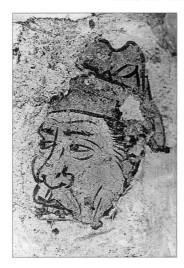

1.4 Middle-aged man, mural, tomb of Lady Xue, Dizhangwan, Xianyang, Shaanxi province, dated 710.

arms widely spread, the main figure has an exaggerated hook nose and round eyes and wears foreign garb—a cloth cap, tunic, and trousers (Fig. 1.5). His musicians, similarly attired, look up at him with expressions of concentration.

Fragments of a mural from the late-Tang tomb of Yang Xuanlue (dated to 864) preserve an unusual portrait of a tall elder scholar in profile, his two hands held before him but hidden in his voluminous sleeves. The drawing of the figure demonstrates a sensitive use of line: varying in width and darkness, an assortment of thick lines describe the drapery, while delicate thin lines render the beard and widely opened eyes. The full profile pose is unusual and foreshadows the well-known idealized portrait of Li Bai by the painter Liang Kai, of the Southern Song dynasty (1127–1279).

By early in the eighth century, a format had emerged in the tombs that reflects a new type of court art. This is the multi-panelled screen, each section of which has a contrasting

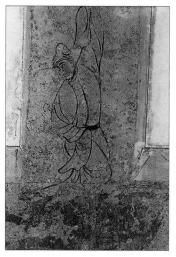

1.5 Barbarian dancer, mural, tomb of Su Sixu, Xi'an, dated 745.

portrait, often against the setting of a single tree. In Astana tomb no. 216, the mural imitating the screen form has a series of gentlemen, probably hermits. Some are seated, while others stand with their hands folded in voluminous garments or gesticulate as if in conversation. An example found in Astana tomb no. 215, dated to 715, has replaced the figures with bird-and-flower studies (Fig. 1.6). Only four of its eight sections are preserved—these show tall grasses and rocks as a setting for aquatic birds drawn in delicate colors.

The popular Tang theme of ladies seated under a tree is found in a mural of the Wei family tomb, located to the north of Weiqu, in Chang'an county, Shaanxi province. Although not dated, the tomb is ascribed by Chinese scholars to the later Tang. Considerably thinner than are the beauties of the Ming Huang era, these ladies are also more conservatively dressed and with more understated hair arrangements (Fig. 1.7). Some are seated, while others

21

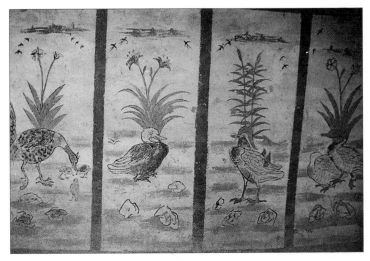

1.6 Birds and flowers, mural, tomb no. 215, Astana, Turpan, dated 715.

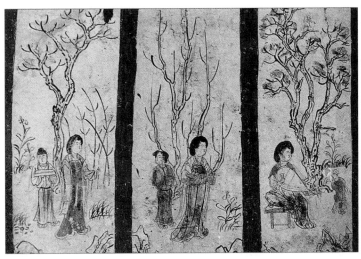

1.7 Ladies engaged in pastimes under a tree, mural, Wei family tomb, Chang'an county, Shaanxi province, late Tang.

stand in a naturalistic garden setting of decorative rocks, shrubs, and trees. They are engaged in leisurely pastimes like those of their game-playing predecessors. One figure warily looks out over her fan into the garden; another, with head turned, looking off into the distance, plays what could be a plaintive tune on a lute—a theme often celebrated in Tang poetry, as in Bai Juyi's poem 'Song of the Lute Player'. In contrast to examples of the earlier Monumental Figure style, these ladies are no longer large-scale, isolated shapes. By showing a variety of postures, different props, and settings, the artist is able to suggest a narrative content altogether absent from earlier examples.

Another mural in the Wei family tomb gives a portrayal of an outdoor party not unlike the banquet scenes found in Han-dynasty funeral paintings (Fig. 1.8). Here, however, the composition is far richer than in the earlier era and displays a more sophisticated arrangement of the pictorial

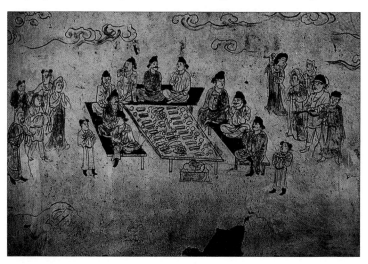

1.8 Outdoor party, mural, Wei family tomb, Chang'an county, Shaanxi province, late Tang.

elements. The guests, seated around a large table neatly set with dishes and cups, are shown in a variety of postures of storytelling, rapt attention, wine-drinking, and calling for refills. Grouped on either side are onlookers, among whom are an elderly man leaning on his cane, youthful servants, a house-steward, and a woman holding a child. In the upper part of the composition are scudding clouds; in the lower left a rock is sketched. The whole is executed in delicate hues of green, tan, and red.

Similar to the Wei mural in theme and mood is a late-Tang painting in the Palace Museum, Taiwan. This shows a banquet for female members of the court, with the revellers seated around a large table set with various small exquisite porcelain cups, lacquer dishes, and other food containers. The women have obviously drunk too much: uncertainly they return the cup to the table or stare blankly out into the distance. With great concentration, others play musical instruments like the lute, flute, vertical pipes, and zither. One youthful standing servant plays the rhythmic bamboo clapper. As these banqueters are court women, they are dressed luxuriantly in loose-fitting gowns with voluminous sleeves and narrow silk scarves. Some wear elaborate headpieces, others have their tresses asymmetrically piled in a topknot that falls to one side. They wear dramatic make-up: white powder covers the bridge of their nose and brow, over which decorative rosettes are painted, and their lips are coloured red. Shown from a multitude of angles, the ladies differ from one another in physiognomy and posture—no two do the same thing in the same way. The furniture is luxuriously appointed, including carved fruitwood chairs with sculptured legs and brocade pillows. Beneath the large inlaid table a small dog is curled up, asleep. Delicate hues of aqua, red, black, and brown dominate the composition.

As is often trumpeted in histories of art, the supreme accomplishment of Tang painting was in its portraiture. High Tang figure painting is characterized by an increasing facility in painting figures with distinctions between race, station, age, character, and mood. At the beginning of the period the images were large and loomed in an undefined space, the overwhelming concern being the proper articulation of the costumes and attributes. Gradually, Tang artists became interested in the depiction of each individual's character and mood. In the later half of the period these contrasted figural subjects began to be shown in a number of different settings, engaged in various daily activities, and with the appropriate expressions and gestures. The inclusion of props and detailing of the figures' surroundings added a narrative content to the images which paralleled contemporary literary concerns—as can be seen in the then new prose genres of the short story and tales of the strange. The development of these pictorial concerns extended beyond the Tang, reaching its climax in the narrative handscrolls produced during the Song dynasty (960–1279).

Horse Painting and Sculpture

The importance of horses to the Tang emperors cannot be overstated. Prized for their speed, endurance, and heart, these noble creatures were indispensable in warfare, hunting, and the aristocratic pastime of polo. During the Tang, steeds and their trainers were imported from the Central Asian regions at often exorbitant cost.

The great warrior Taizong saw his stallions celebrated in poems and works of the visual arts. Portraits of the six chargers who served him in his military campaigns were drawn by the court artist Yen Li-ben and made immortal

by being incorporated into the decor of the imperial funeral mound. Today little remains of Taizong's tomb with the exception of the low-relief portraits of these six treasured mounts. Each horse's individual spirit and beauty are captured through a detailed and naturalistic rendering of its pose, anatomy, and trappings. These skilled representations are evidence of the high level of animal portraiture in the Tang. While five of the horses are shown in rapid movement— at full gallop (Fig. 1.9) or trotting—in the relief of Saluhsi, now in the University of Pennsylvania Museum, the charger

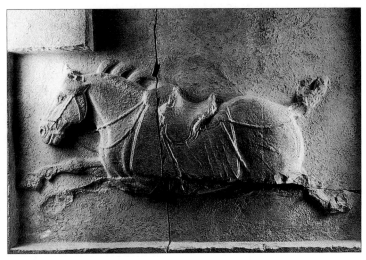

1.9 Taizong's mount, bas-relief, Zhaoling mausoleum, now in Shaanxi Provincial Museum, Xi'an, *c.* 636.

is attended to by the famous commander Ji Xinggong. In the relief, the general calms the mount, whose reins he holds in his hand; the communion between the two is expressed by their head-to-head posture and the responsive stance of the horse as he submits to the general's

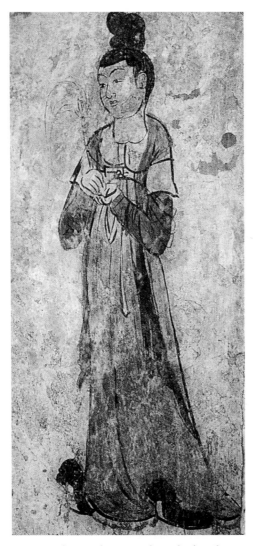

1. Female attendant, mural, tomb of Li Shuang, near Xi'an, dated 668.

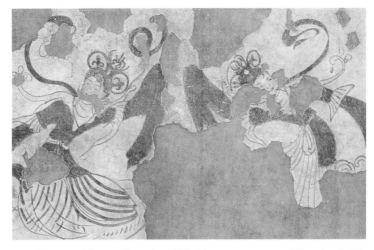

2. Dancing girls, mural, tomb of Li Ji, Liquan county, near Xi'an, dated 669.

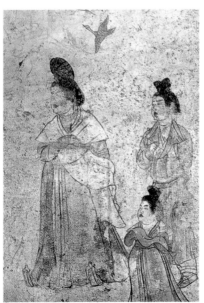

3. Three attendants, mural, tomb of Li Xian, Qianxian county, near Xi'an, dated 706.

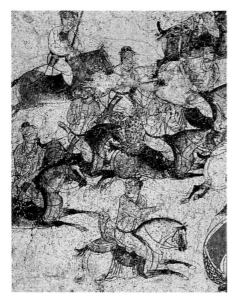

4. Hunting, mural, tomb of Li Xian, Qianxian county, near Xi'an, dated 706.

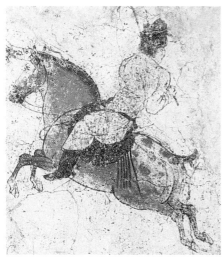

5. Polo player, mural, tomb of Li Xian, Qianxian county, near Xi'an, dated 706.

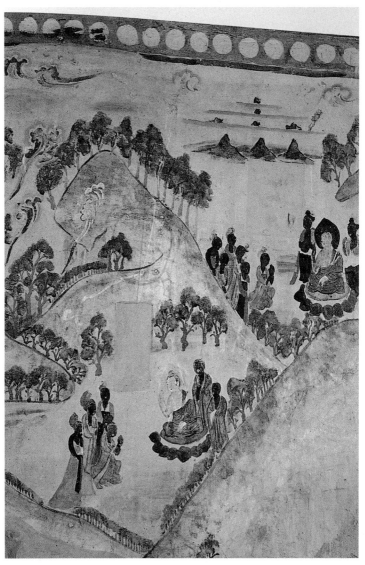

6. Mural, cave 209, Mogao grottoes, Dunhuang, *c.* eighth century.

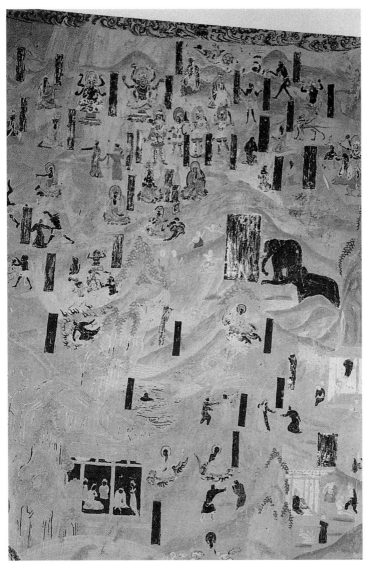

7. Mural, cave 321, Mogao grottoes, Dunhuang, *c.* eighth century.

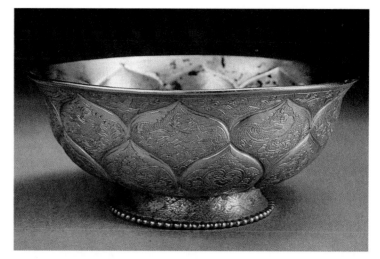

8. Gold bowl, found at Hejia village, Shaanxi province, now in the Shaanxi Provincial Museum, mid-eighth century.

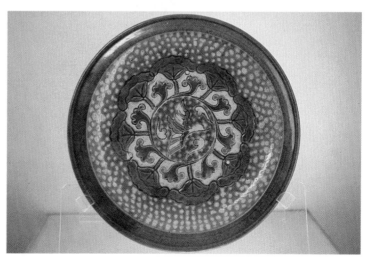

9. Plate with *sancai* glaze, now in Shanghai Museum.

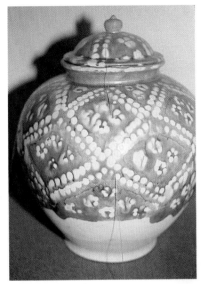

10. Lidded jar with *sancai* glaze, now in Palace Museum, Beijing.

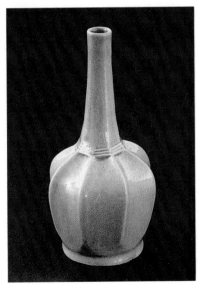

11. Celadon porcelain ewer, Famen temple, near Xi'an, late ninth century.

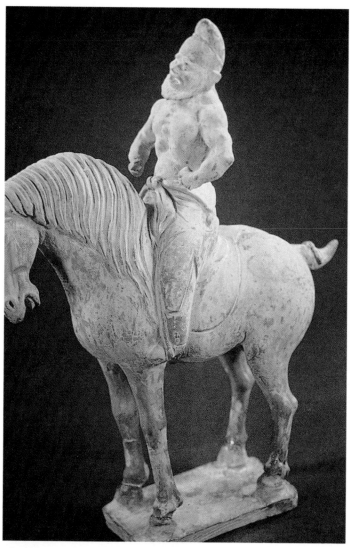

12. Equestrian figure, ceramic, found in the tomb of Princess Yong Tai, Qianxian county, near Xi'an, now in Beijing Historical Museum, 706.

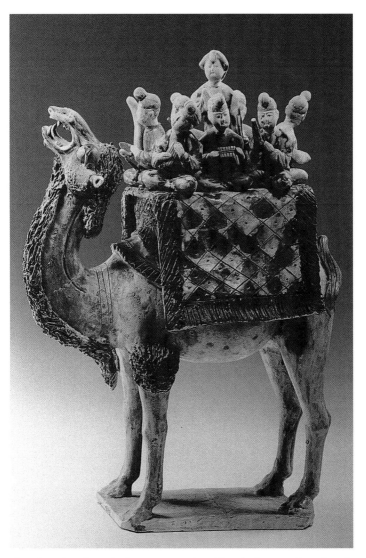

13. Camel and musical party, ceramic with polychrome glaze, found at Zhongbao, Xi'an, now in Shaanxi Provincial Museum, *c.* 745.

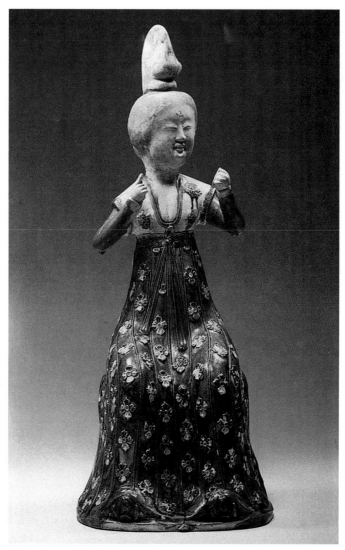

14. Tri-coloured figurine of a lady, found at Wangjiafen, near Xi'an, now in the Shaanxi Provincial Museum, early eighth century.

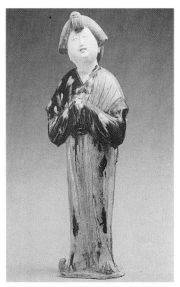

15. Female figure, ceramic with poly-chrome glaze, found at Zhongbao, Xi'an, now in Shaanxi Provincial Museum, *c.* 745.

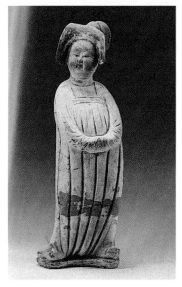

16. Female figure, ceramic, found at Gaolu village, near Xi'an, now in Shaanxi Provincial Museum, dated 748.

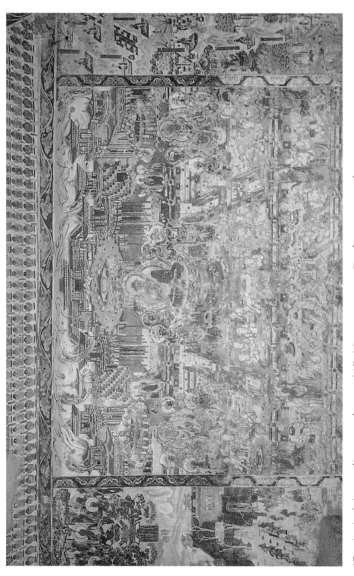

17. Amitofu's paradise, mural, cave 217, Mogao grottoes, Dunhuang, seventh century.

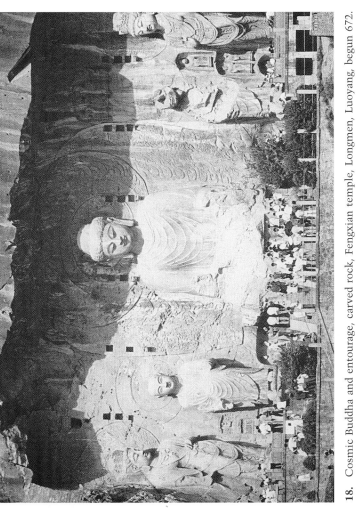

18. Cosmic Buddha and entourage, carved rock, Fengxian temple, Longmen, Luoyang, begun 672.

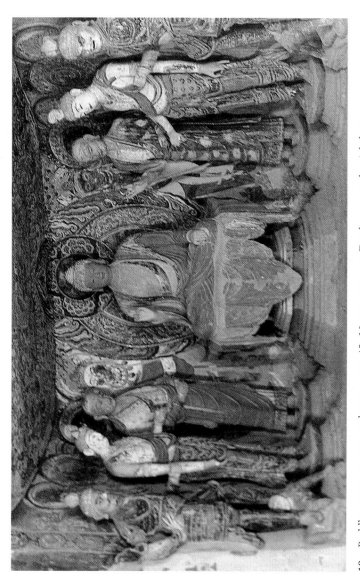

19. Buddha group, stucco sculpture, cave 45, Mogao grottoes, Dunhuang, early eighth century.

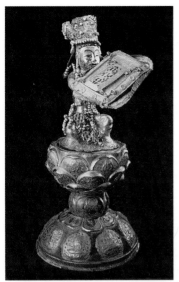

20. Gold and silver sculpture of a kneeling Bodhisattva, Famen temple, near Xi'an, dated 873.

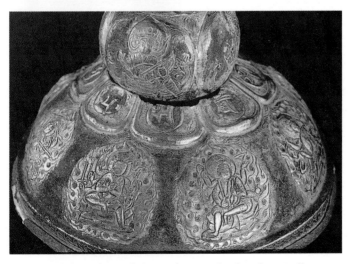

21. Detail from base of the sculpture of a kneeling Bodhisattva, Famen temple, near Xi'an.

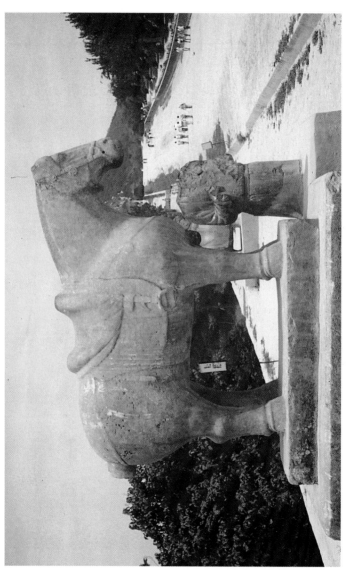

22. Stone horse and groom, Qianling mausoleum, near Xi'an, late seventh century.

ministrations. All six horses are beautifully groomed in Tang style with tails knotted and manes combed.

Like Taizong, Xuanzong was also an admirer of the noble breeds brought from the West as tribute. His love of horses is reflected in the excellent paintings commissioned by his court. Several specialists were active at the time, Wei Wutian, Chen Hong, and Han Gan among them. The ninth-century art historian Zhu Qingxuan related:

When the K'ai Yuan [Kaiyuan] period brought peace to the world, blooded horses were sent hither in relays from foreign lands, although they crossed such wide stretches of desert that their hooves wore thin. Ming Huang used to select the best of these and have them portrayed along with his Chinese coursers. From then on the imperial stables possessed mounts of the 'Flying Yellow', 'Night-lighting', 'Drifting Cloud', and 'Five Blossom' types. They had unusual coats and their whole appearance was remarkable; their sinews and bones were rounded, and their hooves thick.... First they were depicted by Ch'en Hung [Chen Hong] and then by Han Kan [Han Gan](Soper, 1958: 215).

These horse paintings were celebrated by such Tang poets as Yuan Zhen and Bai Juyi. The horses of Ming Huang's court were trained not only to excel in warfare, hunting, and polo but to perform tricks, such as dancing. A short story written in 850 by Zheng Quhui poignantly described the misuse of the dancing horses after Ming Huang's downfall (Waley, 1952: 181–3). Another work, an ink painting attributed to Han Gan and now in the Metropolitan Museum of Art, captures the spirit and nobility of the breed in the horse's facial expression and posture: the mount struggles valiantly against being tied to a stake.

The Tang artists' superb appreciation of the beauty and spirit of horses, however, is perhaps best reflected in the

ceramic horses made as *mingqi*, objects for the tomb (see Chapter 3). These sculptures, some of the best-known objects of the Tang arts, reflect the highest level of artistic expression directed to their subject.

Landscape Painting

Landscape painters were highly revered in Tang histories of art. Li Sixun and his son, Li Zhaotao, in particular are credited as the most accomplished practitioners in Ming Huang's court of the so-called Blue-green style of landscape painting. Their technique is distinguished by a highly decorative appearance accomplished primarily through the use of these two brilliant colours with highlights of gold. Unfortunately, few examples of their art have survived in China. Evidence of their style can be seen in other media, however, such as Tang decorative objects with landscape designs—chiefly musical instruments, silver vessels, and mirrors—housed in the Shoso-in, the imperial repository in Nara, Japan, containing the possessions of the Japanese emperor Shomu. Many of the Shoso-in pieces are Chinese, Korean, or Japanese copies of Tang objects. Before the rich Chinese archaeological finds of recent decades, the Shoso-in was one of the few documented sources of Tang art.

The landscape settings in figure paintings also provide a glimpse of the lost art. In the imperial tombs of Li Zhongren, tree and rock forms are drawn with a cursive brush whose contours change in width so as to convincingly suggest three-dimensionality. Light tones of brown brush strokes enhance the rocky appearance of the land-forms and suggest solidity through modelling. Unlike Western-style modelling, which uses contrasts of light and shade, there is no uniform light source; the application of lighter and darker tones only suggests random highlights and shadows.

Other examples of Tang landscapes may be found in details of Buddhist murals, such as those in the Mogao grottoes, near Dunhuang in Gansu province. This Buddhist cave site, situated at the edge of the Gobi desert, was important for its location at the western end of the Chinese section of the Silk Road. Hundreds of caves were excavated out of a sandstone bluff and decorated with stucco sculptures and colourful murals. Merchants, missionaries, and the local people directed their prayers to the deities portrayed in these murals and sculptures for divine help in their transactions and against the difficulties of desert life and travel. The site was in use as early as the fifth century AD, but the majority of the caves were opened under the Tang.

As this is didactic painting, the figures in the Mogao murals are large in relationship to the landscape elements. Despite the demands of continuous narrative requiring independent episodes, however, the artists often set the events in a unified mountainous landscape, distributing the different scenes in distinct spatial areas. Since the time of the Han dynasty, landscape had provided a setting for figural action, but the landscape vocabulary of trees, grass, rolling hills, and decorative garden rocks was not portrayed with a developed sense of foreground, middle ground, and background or deep recession. In the sixth-century space of the Mogao caves, cells comprised of landscape elements (such as hills, trees, and rocks) were arranged as a stage for figural activity and loosely linked across the picture plane like a string of pearls. During the Tang, a unified pictorial space was created by forging groups of cells together into a dramatic illusionistic space.

Two landscape techniques using the Blue-green style are identifiable at Dunhuang. The first, seen in cave 209 (Plate 6), uses fluid black brush strokes, as in tomb murals, to create the contours of the landscape forms. Variety in

the width of the outline and fine interior drawing suggest three-dimensionality. Colour is applied decoratively. The second, employed in cave 321 (Plate 7), manipulates broad washes of brilliant blue-green and earth colours—outlines are entirely absent. Highlights and shadows are created with darker and lighter tones of these hues.

At Dunhuang, there are even rare cases of isolated passages of landscape which appear to be free of figural activity, and were probably meant as space filler, as in the well-published cave 217, painted using the second of these two techniques. These examples are evidence of the growing autonomy of landscape as a pictorial subject, an independence the theme had long enjoyed in literature.

A high esteem for landscape painting is apparent in the literature, as in the poetic description by Zhu Qingxuan of the work of Zhu Shen:

His renderings of precipitous ridges and the subtlety of his successive distances; the limpidness of his lake tones and the splintery look of his rock markings; the peaks that towered upwards under his brush, and the clouds that mounted from its tip; the ravines and sombre depths that he set within an inch or two; his intermingling of pines and bamboo groves, and the gloom or pallor of his clouds and rain: all these, although they were invented by his predecessors, were made by [Zhu] into models for later generations (Soper, 1958: 218).

The poet Du Fu's ode to the landscape artist Wang Zai captures a similar respect for the artist's accomplishments:

Ten days to paint a rock
Five days to paint a stone
An expert is not to be hurried
Only so will Wang Zai leave you one of his
 authentic works (Soper, 1958: 219).

Unlike artists of earlier in the Tang, those of the late eighth century were free to represent nature without including figures in a narrative within it. Thus, Wang Zai is credited with the painting of a screen showing only two trees. Other landscape subjects popular at the time included depictions of the four seasons. Just as officials in distant provinces were requested to compose poems about their respective regions, so too a governor of Lianzhou (in Guangdong province) was asked by the emperor Dezong to regularly submit to the court paintings of the scenery of that area. By the end of the Tang there was further specialization in the depiction of landscapes, rendering them under specific atmospheric conditions and times of the day. During the reign of Xizong (r. 873–88), Chang Xun, known for his mountains and cliffs, dead pines, and strange rocks, painted a mural of three landscapes at Zhaoxue temple. His view of dawn, noon, and dusk, the three times of day, drew favourable comments from the emperor and served as a model for painters of future eras.

Painting in the Late Tang

Artistic remains from the late Tang are few, but history attests to the continued production of art at court during those troubled times. It is believed that several artists even accompanied Xizong to Sichuan in 880–1, when the emperor was forced by rebels to flee his capital. Many Tang painters worked in specialized genres only, treating figure, horse, or landscape subjects, and this tendency grew more pronounced in later centuries. The late-Tang artist Bian Luan, for example, would paint only birds and flowers. This kind of specialization anticipates a stage in painting dominant later and reflected in the art histories—such as Guo Roxu's

Tuhua Jianwenzhi—by the arrangement of artists according to their speciality, not their social rank.

The gradual elevation of the artist in the Tang social hierarchy is also evident in the changing ways in which emperors dealt with the painters at their court. Court records of the later aesthete emperors, such as Ming Huang, catalogue the high rank and social preferences lavished on favourites. Without doubt the most celebrated and honoured by the court was Wu Daozi, called at the time the greatest genius of the brush, especially in the field of landscape painting. Even the way in which emperors approached their subjects to request works of art changed by the later Tang. In contrast to the slight felt by the painter Yen Li-ben, commanded to perform by the emperor Taizong, the eminent portraitist Zhou Fang was only indirectly approached—through his brother—by the emperor Dezong.

The elevation of the rank of the artist in society was also reflected in the ability of an artist to advance solely on artistic merit, rather than social standing, which was seen for the first time at the opening of the ninth century. By the later Tang, the status of the artist stood midway between a court attendant and the emerging ideal of the independent creator that dominated the art of the next great dynasty, the Song.

2

Gold and Silver Articles

ALTHOUGH OBJECTS of gold and silver were known in ancient China, they were not found in great quantities. The Tang's high esteem for such precious metals was due largely to influences from the West: it was not until the great increase during the Tang in commerce along the Silk Road that such articles became popular in China. Although articles of intrinsic worth inevitably have little chance of survival, fortunately a wealth of material has recently been uncovered in a number of archaeological finds. The evidence found has supported a conclusion that ownership of gold and silver objects was widespread during the Tang era and has helped to establish a specific chronology for the development of gold and silver luxury goods.

The majority of the evidence was found in two caches, each comprised of hundreds of silver and gold articles. The first discovery was made at Hejia, a village outside of Xi'an, and the other in Dantu county, Jiangsu province. In addition, materials have been uncovered in several individual tombs from the late Tang, and an important group of treasures were found in 1987 in the underground vault of the Famen temple, west of Xi'an. Ancillary material giving information about Tang arts is housed in the Shoso-in.

The archaeological evidence establishes that by the end of the seventh century, during the reign of Empress Wu, gold and silver articles were abundant in China. Characteristically, the objects of this first stage were made in a style heavily dependent on Western prototypes—which is not surprising, as Wu's court was well-known for its international spirit and the presence within it of Western

artists. Although Western influences are still apparent in products of the second phase of production, which ended with the fall of Chang'an in 756, a more Chinese aesthetic had emerged by that time. The new style is evident in the shape of the vessels, as well as in their decorative themes. The final stage, which lasted from 756 to 880, is wholly Chinese in technique, type of object, and embellishment. Each of these three periods has its own characteristic designs, methods of manufacture, and vessel types.

Most of the objects obtained from the caches at Hejia and Dantu are believed to have been made during the second period and buried in haste with the advance of An Lushan's rebellious troops in 756. The range of articles within the Hejia material is great: three bowls of solid gold, forty-five smaller silver bowls, and fifty-one plain silver plates. Of the twenty-seven drinking vessels, five are gold, twelve silver, and five jade. There were no fewer than fifty-one utensils for the preparation of medicine in the group.

Articles thought to be from the first stage were also present, and these reveal Western influences in their shape, technology, and design. The forms of faceted cups, cups with handles, stemmed cups, and lobed cups with flat handles are all of Western inspiration. One excellent representative of a first-stage design from the Hejia materials is a small, octagonal, footed gilt silver wine cup with a round handle (Fig. 2.1). Each of its eight facets shows a vividly projecting musician against a background of granulation with scattered landscape motifs, birds, and plants.

Most of the objects found at Hejia, however, are thought to belong to the second phase, specifically from the reign of Ming Huang. These articles are magnificent in appearance and evince complicated techniques, such as the punched-out decor of a small gold pedestal bowl, whose sides have

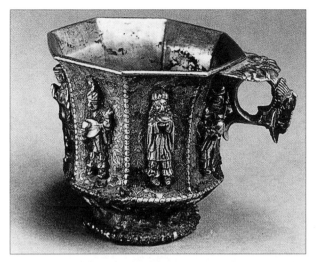

2.1 Octagonal, footed, gilt silver wine cup with round handle, found at Hejia village, Shaanxi province, late seventh century.

been shaped into lotus petals and engraved with ornamental deer, birds, and flowers (Plate 8). Although the bowl makes use of the repoussé technique imported from the West, it has been attributed to this later period because of its delicate floral background. Not only is the body of the bowl covered with delicate floral patterns and a background design, but the bottom is engraved as well. On the belly of a larger silver kettle with lid is a raised golden prancing horse drinking from a cup (Fig. 2.2). Both the kettle's shape and its golden lid, attached to the handle by means of a chain, are clearly in imitation of a 'Hu barbarian' people's jug, but the subject of the decoration is one of the dancing stallions held in such high esteem and celebrated in paintings and poems at the brilliant emperor's court.

The second hoard of precious metal objects, that found in Dantu county, is comprised of 950 pieces, 760 of which

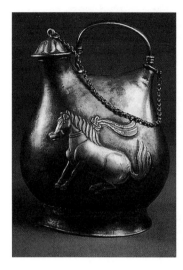

2.2 Silver kettle with horse drinking from a cup, found at Hejia village, Shaanxi province, mid-eighth century.

are hairpins. Many of the vessels are inscribed with the single character 'Fang', which some believe is the name of an official who tried to save his treasures by interring them. Included among the hundred-odd larger articles are silver bowls, covered boxes, and ewers, but most of the pieces are plates. Many of the smaller objects, such as spoons and bracelets, are engraved with fine naturalistic floral and bird designs. In addition, there are a golden incense burner and an inlaid silver and gold drinking-game candle. Several multi-lobed boxes have intricately worked designs of a decidedly greater dimensionality than that seen on the Hejia material. Often, the Dantu pieces have a raised design of flying paired birds against a fine punched-ring background.

In the second phase of gold and silver vessel manufacture, new forms had replaced the Western prototypes of the previous century. Foremost among the new forms were replicas of natural objects, such as a hinged clam-shell box

from the Hejia finds or a Dantu covered dish made to resemble a lotus leaf, curling at its edges with its stem upright at the centre. Many silver objects show an admixture of decorative techniques, even being inlaid with gold designs. In Li Jinguo's tomb, dated to 738, were found several exquisite silver boxes and bowls whose style is quite similar to that of the Hejia material. One gold inlaid silver box has the six-lobed shape of an open flower, while another replicates a hinged clam-shell box and displays delicate gold floral and bird designs against a ring-pattern background.

Most of the finds ascribed to the third period of production were unearthed at the Famen temple, but a few tombs have also yielded silver and gold articles from this period. Famen temple is located about 100 kilometres outside of the ancient capital, Chang'an. After the temple's pagoda collapsed in the early 1980s, the restoration team uncovered three subterranean treasure vaults filled with precious ritual objects. The Famen finds were startling, because many scholars had assumed that articles fashioned from precious metals during the late Tang were neither skillfully made nor numerous. As a consequence, all works of extraordinary craftsmanship in precious materials were commonly ascribed, both in China and elsewhere, to Ming Huang's reign. In fact, gold and silver production prospered after 756, and historical records now reveal that the practice of giving gold and silver to the emperor reached its peak during the late eighth-century reign of Dezong, at which time officials competed in giving opulent gifts.

Late Tang tombs produced several examples of a type of large plate having a raised central motif of an animal in profile. There are four such dishes dated to Dezong's reign. Although this style originated earlier, several examples being found in the Hejia horde, it apparently had become quite popular by the end of the eighth century. A silver

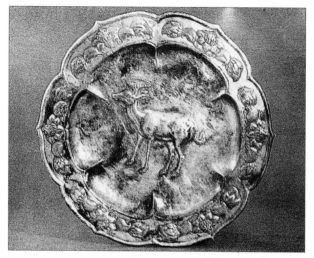

2.3 Plate with central motif of a standing deer, late eighth century.

plate found in Liaoning province and dated to 796 has a central design of a reclining stag. Another, fashioned from gold and found in the ruins of the Daming Palace, the principal residence of most of the Tang rulers, has been dated 780–802 and has a double phoenix. A third (Fig. 2.3), made of silver and thought to be a contemporary of the others, has a standing deer modelled in raised gold; it was found in 1984 in Guanzheng, Hebei province. Often, the perimeter of these plates is treated as a six-petalled, open lotus flower. In such cases, each lobe may be adorned with a vegetal or floral spray. Some, such as the plate found in Hebei and a similar example in the Shoso-in, rest on three feet.

This type of plate, with a raised animal at the centre, was executed in other materials in addition to gold and silver. A large copper platter (Fig. 2.4), found in the Kengdizhai section of Xi'an and dated to Dezong's reign, has a raised

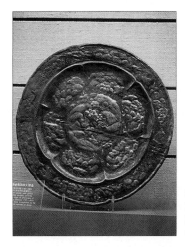

2.4 Copper platter found at Kengdizhai, Xi'an, now in Shaanxi Provincial Museum, late eighth century.

double phoenix as its central theme and peony clusters modelled on the six peripheral lobes. Platters like these continued to be found in the late Tang, as one dated to the reign of Dazong (r. 846–59) attests. Other popular shapes of the late period are a silver bulbous jar with elongated foot, narrow neck, and wide lip, and a lobed covered box, such as the beautifully wrought, five-lobed silver box, inscribed with a date of 866, found in a tomb in Lantiantang, Shaanxi province. Replacing the ring background ornament of earlier eras is a delicate vegetal pattern; embossed on the surface of the lobes are paired birds and at the centre two mythical phoenixes in flight.

More than one hundred gold and silver articles made in the late Tang were found in the basement of the Famen temple. Those that have a clearly identifiable ritual function are discussed in Chapter 4. Many, however, have no apparent religious purpose. Among these, decorative boxes are plentiful, including several covered boxes of silver or gilt silver. A most skilled example is naturalistically shaped and decorated to resemble a turtle (Fig. 2.5).

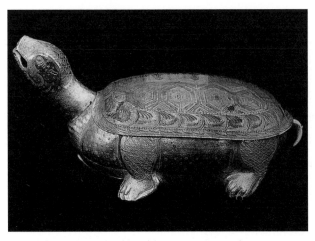

2.5 Gilt silver turtle-shaped box, Famen temple, near Xi'an, late ninth century.

The silver and gold articles devoted to the tea ceremony and donated to the temple by the emperor Yizong (r. 859–73) include cups and saucers, tea caddies, a grinder that pulverizes the leaves, ladles, and a spice cellar to hold condiments. Tea-drinking proliferated in Tang China. Originally associated with Buddhism, tea was found to be an excellent aid in meditation. The popularity of the custom during the Tang is reflected in Lu Yu's *Chajing* (The Classic of tea), written late in the eighth century, which offers advice on the various types of tea plants, methods of cultivation and harvesting, and types of porcelain most suitable for use in drinking tea.

Among the Famen items, one remarkable silver tea caddy has tiny engraved and gilt narrative scenes of sages in a landscape: they play music, chat with one another, or play a board-game (Fig. 2.6). The lid is shaped into lotus petals, each petal carved with floral designs and inset with gilt animals in chase. Crowning the top is a lotus bud. A tea

40

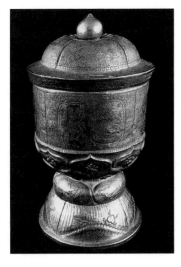

2.6 Gilt silver tea caddy, Famen temple, near Xi'an, late ninth century.

mortar with grinding wheel is an elongated vessel, 20.7 centimetres long, made of silver with gilt animals and stylized cloud patterns. A gilt-footed tea leaf basket, 17.8 centimetres tall, is of openwork silver. The handle and lid are affixed with a link chain, and twenty-four gilt paired geese fly around the circumference while fifteen are found on the lid. Also in the collection is a salt basin, on a tripod base, fashioned with a lotus leaf cover (Fig. 2.7); the bud at the top opens to hold condiments for tea-making.

Mirrors

Since the time of the Zhou dynasty (c. 1100–256 BC), bronze mirrors had been cast in China for their magical powers. Their decorative vocabulary was usually comprised of auspicious images for the prolongation of life, protection from evil, or rebirth in a Daoist paradise. Most frequently,

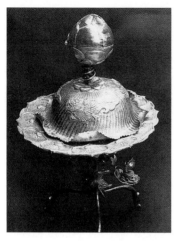

2.7 Gilt silver condiment holder, Famen temple, near Xi'an, *c.* 870.

mirrors were associated with the performance of alchemy and Daoist ritual. Judging by the lore of the mirror, its magical properties were considered more important than was its cosmetic function. However, 'Admonitions of the Court Instructress', a painting in the British Museum by Gu Kaizhi, of the Eastern Jin dynasty (AD 317–420), illustrates the mirror's use as a toiletry article. Poems of the late Tang, such as Li He's 'A Girl Combs Her Hair' or Du Mu's 'On the Road', which begins 'Sadness at the silver hairs in the mirror is new no longer...' (Graham, 1965: 115), further celebrate a beauty looking into a mirror.

Tang mirrors appear in the greatest variety of shapes with a wide range of ornamental themes. No longer limited to being square or round, Tang mirrors were formed like radiating petals or were multi-lobed, like the gold and silver dishes discussed above. Not made solely of bronze, mirrors were inlaid with silver or gold, with mother-of-pearl, or covered with lacquer. Still popular were the symbolic designs of the animals of the four directions, emblems of time and

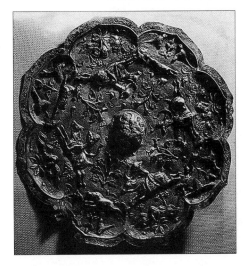

2.8 Silver mirror with hunt scenes, Tang Historical Museum, Xi'an, early eighth century.

space who have spiritual and apotropaic powers, and the animals of the Asian zodiac. Other mirrors display Daoist themes, such as the preparation of the elixir of immortality, the hare pounding an herb-filled mortar in the company of winged immortals and deer. There are even isolated illustrations of ancient history.

Some Tang mirrors carried landscape motifs, while others had designs of mountains and rivers, or sages seated in a garden setting. One meticulously detailed eight-lobed mirror has four hunters in a flying gallop shooting deer (Fig. 2.8). Against a granulated background are raised designs of scattered flowers, and in the lobes are small landscapes of mountains, trees, and scudding clouds alternating with a theme of paired birds flanking a flower.

The symbolic content of other subjects is less clear. For example, the common 'lion and grapevine' motif, surely of Western derivation, may have had a relation to the Greek cult of Dionysus, but the connection has long been lost.

3

Ceramics

TANG CRAFTSMEN were successful in producing a wide variety of ceramic wares, and connoisseurs have since come to regard their figurines as among the greatest achievements of that genre. During the Tang, polychrome glaze was developed and began to be employed for both utilitarian objects and figurines. In the latter part of the dynasty true porcelain was manufactured for the first time.

Most of our knowledge of Tang ceramics has come from objects found in tombs. Judging by the hundreds of pottery figurines found, including depictions of animals and people, as well as plates, teapots, cups, dishes, and bowls, it is clear that ceramic manufacture was a growing industry. The number of kiln sites and regional styles uncovered indicates that by the middle of the Tang era there were at least thirty production centres in the ten provinces (Li, 1972: 34–48). Naturally, with the increase and spread of production came a number of developments in the construction and decoration of ceramics. A variety of forms evolved, as well as several modes of decoration, different kinds of glaze, and new techniques for applying glazes and constructing vessels.

Glazes

During the Sui dynasty, and to a lesser extent as early as the Six Dynasties period (222–589), pottery was coated with clear tinted glazes that turned glassy and slightly yellow or green when fired. One method of applying the coating,

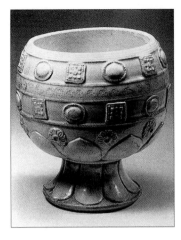

3.1 White porcelaneous footed bowl, found at Hansenchai, Xi'an, dated 667.

dipping the vessel into the glaze, resulted in an uneven overlay and drip marks. A few such glazed vessels, rough in shape, relatively large in size, and displaying incised or raised floral designs, can be dated to the early Tang period. A white porcellaneous footed bowl, taken from a tomb in Hansenchai, a section of Xi'an, and dated to 667, is an excellent example of this type (Fig. 3.1). A high foot meets the bottom of the basin to create a lotus flower design, while applied jewel and medallion shapes project from the surface of the bowl.

The second stage in the development of lead-glaze ceramics was the creation of chromatic glazes. The addition to the glaze base of the colouring agents copper oxide and iron oxide results in green and brown-and-yellow glazes, respectively. In the Tang, these three colours, together called *sancai*, were used for decoration on figurines and vessels, producing some of the most highly prized and characteristic ceramics of that era. To achieve these effects, the glaze is melted down in combination with other components into

a glassy state which is quenched in water, shattered, crushed, finely ground, and finally, mixed with water, applied, and fired (Medley: 1981: 24).

The earliest coloured glazes made in China are found on pilgrim flasks, a type of vessel borrowed from the West which bore an impressed ornamentation. Their colours range from dark brown to dark green. Other pieces imitating Persian metal ewers, such as one in the Shaanxi Provincial Museum, have raised designs and caps shaped as dragons or fanciful birds' heads. Although appearing less frequently than the others, a blue glaze that uses cobalt brought from Persia has also been found. Figurines were also treated with coloured glazes, as those of Zheng Rentai's tomb dated to 664 demonstrate. The effect of the earlier efforts, however, is rather jarring, as control of the spread of the glaze was poor.

At kiln sites in Luoyang and Gongxian, in Henan province, the preferred ceramic form was made of a fine white kaolin clay. Forms from Chang'an, however, had a light pink coloration and so a technique was developed that provided a neutral base for the glaze by covering the object with a fine slip made of liquid clay. As this innovation also helped the glaze to adhere more smoothly to the object's surface, it was soon widely adopted.

Other techniques evolved to control the spread of the coloured glaze and to control dripping by adjusting the viscosity of the liquid. Engraving lines around specific areas helped prevent the glazes from slipping, a technique used on a *sancai* plate displaying an inscribed design of a central lotus flower and now in the Shanghai Museum (Plate 9). Wax grease was applied in areas to make them resistant to colour. Occasionally the glaze was painted on with a brush. A tall covered jar now in the Palace Museum,

Beijing, shows how Tang artists experimented with the wax-resist technique to create a design of linked lozenge motifs and lotus flowers in the *sancai* style (Plate 10).

Porcelain

Porcelain is made from kaolin clay mixed with petuntse (also called Chinese stone). At high temperatures it changes its physical composition and vitrifies. After the first firing, the vessel is usually coated with a glaze and refired, producing a glossy, glass-like surface. Continuous experimentation and refinement in ceramic production during the Tang resulted in a great variety of porcelain vessels, many of which were employed for the relatively new custom of drinking tea. While white proto-porcelain wine cups and teacups were found in the Beijing tomb of a Daoist and dated to 745, it appears that it was not until the late Tang that vessels made of porcelain came into common use.

Recent archaeological finds have established that the pure, creamy white porcelain vessels known as Xing ware originated in the Hebei/Henan region during the Tang. Their colour, once described as silver or snow, was long held to be an achievement of the potters of the Song dynasty, but excavations at the Dingzhou kilns in Hebei as early as 1941 have established that white ware was already in production at that location during the ninth century. Evidence for the antecedents of Xing ware is as yet lacking (Medley, 1981: 80; see also Li, 1972).

Tang tombs uncovered in Hebei and Henan provinces have provided several examples of the thin-walled, luminous white porcelain. Typical shapes found have included bowls with wide lips and narrow feet, and ewers, often with funnel

3.2 White porcelain wine cup, found in the tomb of Li Cun, Yanshi, Henan province, now in Beijing Historical Museum, dated 845.

tops, short spouts, and flat handles. In the tomb of the official Li Cun, buried in 845 in Yanshi, Henan, were several kinds of porcelain objects, including a small unadorned wine cup with a four-lobed body supported by a low foot (Fig. 3.2), a wide-shouldered jar with a small mouth and lid, and a spittoon with a broad funnel top and bulbous body. All three of these vessels are based on metallic forms, a characteristic of early porcelain shapes.

Two late Tang tombs excavated in Hebei, one dated by a tomb record to 856, similarly yielded white porcelain pieces, several of which were inscribed with the character Zhang, now believed to be the artist's name. These included two small delicate and refined wine cups in the four-lobe shape, plain but for incising around the rim. A third cup,

differing slightly in the configuration of its low foot, and a tall, long-necked ewer with handle were also uncovered. By the middle of the ninth century white porcelain was used for large vessels, such as tall, bulbous, covered jars, as well as small ones, such as a covered bowl with knob lid and delicate wine cups.

Also renowned among Chinese ceramics of this period are the beautiful greenish-yellow Yue wares made in Zhejiang province. Ceramics of the Yue region were well-known and widely traded during the Tang: Excavations at Samarra, not far from Baghdad, have yielded several pieces which attest to Chinese commerce with the Near East. Yue wares were also long celebrated as products of the Song, but recent excavations have verified their Tang origins. One of the few dated Yue wares comes from a tomb dated to 810 (Medley, 1981: 103, fig. 94). It is a short-spouted ewer with handle done in the characteristic yellow-green glaze of the area. As early as the eighth-century *Chajing*, Yue ware was mentioned as exceptionally fine for drinking tea, as it cast a jade-like colour on the liquid. Later Tang examples are often flower-shaped, decorated with delicate line engraving, and occasionally gold-rimmed (Medley, 1981: 101–19).

A group of porcelain celadon vessels found at the Famen temple took the art world by surprise, for this type of ceramic object was also believed not to have been produced prior to the Song dynasty. Discovered in the temple's subterranean treasure rooms were a long-necked jar with an octagonal bottom (Plate 11) and low, wide-mouthed bowls. It has been speculated that silver bands once adorned the feet and rims of these pieces. Both their celadon-coloured glaze and their simplicity of form anticipate the refined style of Song ceramics.

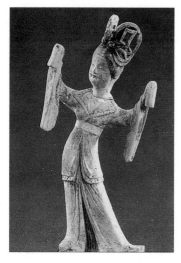

3.3 Figurine of a dancing girl, ceramic, found in the tomb of Mengjin, Luoyang, dated 701.

Figurines

The most impressive group of Tang ceramic creations, figurines were apparently made only to be buried with the dead. Early in the dynasty they were for the most part unglazed, stiff, columnar forms whose limbs remained close to the body and which appear to represent generic types rather than individual portraits. An early Tang tomb, excavated in Changzhi, Shanxi province, and dated to 637, yielded over two dozen such examples, including guardians, officials, ladies-in-waiting, horses, and an ox-drawn cart, as well as utilitarian objects.

Evidence of the artists' growing confidence in creating boldly projecting forms is seen in a figurine, found in a Luoyang tomb and dated to 701, representing a dancing woman (Fig. 3.3). Her arms spread widely to each side, the figure is fully engaged in the dance. In a style similar to that seen in tomb murals of the same era, her hair is drawn

50

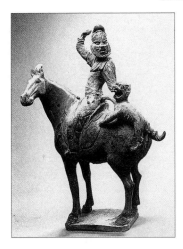

3.4 Equestrian figure, ceramic, found in the tomb of Princess Yong Tai, Qianxian county, Xi'an, now in Shaanxi Provincial Museum, 706.

up and arranged in arabesques on top of her head. More than forty-two pottery figures, including ten musicians, two female dancers, nineteen guardian figures, female attendants, and animals, as well as utilitarian ceramic pieces, were found in this tomb.

By the first decade of the eighth century there was an unprecedented variety and number of figurines, as finds from the four imperial tombs in the Qianling complex demonstrate. The tomb of Li Xian held 777 pieces: lions, camels, horses, and mythological creatures, as well as human figures. Throughout the complex, the figurines were endowed with an extraordinary naturalism and display a specific character often reacting to a certain situation. In one example, an equestrian figure from the tomb of Princess Yong Tai, a foreigner dressed in typical garb—wide, belted tunic, trousers, boots, and a low, tied cap—turns in his saddle to ward off the attack of a wild animal (Fig. 3.4). His horse, standing calmly despite the claws digging into its flanks, bears remarkable testimony to equestrian training and equine character.

Hu people were a popular theme for the Tang ceramic artist: a bearded, half-naked Hu rider (Plate 12), also found in Princess Yong Tai's tomb, sits astride his horse, both hands tautly grasping the reins (now lost). His head is thrown back, open-mouthed and yelling, and his muscles are tense. His horse appears to have only just responded to the rider's command to stop—its head is drawn in by the closely held reins.

Early in the Tang period, glazes were applied to figurines selectively and conservatively. Usually only the head or parts of the mount of an equestrian figure would be treated with the clear glaze, and decorative colouring would be applied by hand after the piece was fired. One fine example of a partially glazed piece, dated to 664, is a figurine of an official taken from Zheng Rentai's tomb, opened in Liquan County, Shaanxi, in 1971 (Fig. 3.5). The figure wears elaborate court dress decorated with borders of rich floral designs. Although his head has been treated with a clear glaze, the details of his facial features and garments were painted by

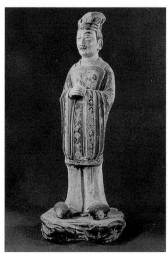

3.5 Figurine of an official, ceramic, found in the tomb of Zheng Rentai, Liquan county, Shaanxi province, now in Shaanxi Provincial Museum, dated to 664.

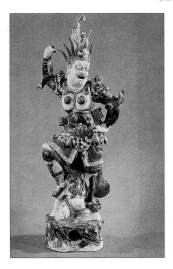

3.6 Figurine of a heavenly guardian king, ceramic with *sancai* glaze, found at Zhongbao, Xi'an, now in Shaanxi Provincial Museum, *c.* 745.

hand after the firing. Most of the 352 ceramic pieces found in Zheng's tomb have been entirely hand-painted, while only a few were partially glazed.

Another decorative effect is created by the combination of white kaolin clay and enriched clay to create a rich swirling pattern. The coat of the mount of an equestrian figurine may have the combined effect of marbled clay and a rich chestnut-coloured glaze. More frequently, marbled clay was utilized for decorative plates and bowls, several excellent examples of which are in the Shanghai Museum.

By the middle of the eighth century the glaze was expertly applied, as on any of the dozens of glazed figurines found in a tomb in the Zhongbao section of Xi'an and dated by the presence of coins to the Kaiyuan era of Xuanzong's reign. On a figure of one of the four *tianwang* (guardians of the cardinal directions)(Fig. 3.6), the armour is made up of different parts—monster-head sleeves, shoulder-pads, breastplate, skirt, and shin-guards—each of which is

individually treated with *sancai* glaze applied in stripes, as mottling, and as dotting. Here the figure's right arm and drapery project boldly, and his body is in a posture of violent torsion: the head is turned to the left, the upper body twists to the right, the hips swivel left, the right knee is bent, the right hand is raised in a fist. His bulging eyes glare fiercely, while his snarling mouth reveals fangs. The torsion of the body enlivens the belt strings and skirt which flare out from the figure. Spiked 'flame'-style hair provides the base for a tall standing bird, while beneath the guardian's feet squats a naked demon, an overweight, disfigured creature with contorted features and curly red hair and beard.

Figurines of the first half of the eighth century are all evocatively drawn, sharing the interest in portraiture seen in court art of the time, and animal figurines similarly reflect the high level of animal painting at the Tang court. The camels found in the Zhongbao tomb have their necks up-stretched, their mouths agape, calling out. One has a musical party on its back, a romantic evocation of the exotic concerts led by Central Asian entertainers (Plate 13). The animal rears its head and bellows—even the tongue and teeth in the mouth are rendered. Three-dimensional, roughly textured clay is used for the tufts of hair on its head, throat, and front legs. Six foreign musicians sitting in decorous postures and playing horizontal and vertical pipes and a stringed lute encircle a figure performing the sleeve dance. Parts of the group are treated with coloured glaze: the camel is a light tan; the garments of the musicians and the saddle blanket are in tones of green and brown, but the faces of the figures are unglazed.

At the beginning of the eighth century, despite the variety and detailing of the portraits, female figurines were not as numerous as were depictions of Chinese and foreign men.

What female figurines have been found, however, reflect an ideal nubile beauty that is slim and youthful. A figure found at Wangjiafen, a suburb of Xi'an, has a most artful application of the *sancai* technique on her gown (Plate 14). The skirt is glazed green and small floral designs, raised from the surface in imitation of brocade, are treated with brown and yellow glaze. The low-cut bodice, showing a Western influence in its daring exposure of cleavage, has a white glaze background against which are raised green floral designs. As is typical in these *sancai* figures, the face, hands, and chest are unglazed and hand-painted in flesh tones.

By the middle of the century the number of female figurines had increased as a proportion of the whole—and some of these were even equestrian figures dressed as foreign males. A large percentage of the seventy articles found in the Zhongbao tomb were female figurines (Plate 15). The ideal of beauty had changed: these figures have rotund shapes that narrow at the base. Their heads support voluminous coiffures that settle in a large loop at the centre of the forehead while the rest frames the face, draped like a thick cap at the sides. The tilt of their heads suggests a mood, and their pear-shaped faces are dimpled, delicately featured, and exotically made-up. Black dots often accentuate either side of the mouth and a red dot is in the middle of the forehead. The garments, high-waisted gowns with a scarf drawn over the left shoulder, are glazed. The glaze effects are diverse: splashed, mottled, and dripped areas contrast with monochrome patches.

Ceramic production saw profound changes at the mid-point of the eighth century. By 742 the manufacture of Tang figurines was so prolific that sumptuary laws sought to decrease both the size and number of figures permissible

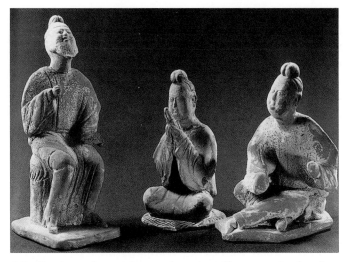

3.7 Figurines of musicians and a storyteller, ceramic, found at Hongqing village, Xi'an, now in Shaanxi Provincial Museum, late eighth century.

for the various official ranks (Mahler, 1959: 130). As a result, there was a clear fall-off in the production of ceramic figurines. In addition, the three-colour glaze technique was abandoned at about this time. The reasons for the abandonment of *sancai* glazes are unknown, but some scholars have speculated that the rebel forces that occupied the capital in 756 interfered with the kilns' administration. Others believe that *sancai* was prohibitively expensive, or that the lead-based glazes, despite the fritting technique used to minimize their toxicity, were found still to be poisonous.

The female figures of the mid-eighth century are ideal beauties rather than individual personalities. Their bodies have grown heavier: the unglazed figurines in the tomb of the military official Wu Shouzhong in Gaolou village, Xi'an,

dated to 748, have a swollen form even more exaggerated by their stance (Plate 16). The belly projects forward in a pronounced way, and the shape of the figure curves downwards, tapering at the feet. The garment, an untailored gown with capacious sleeves, extends beyond the shoes and eddies in pools around the ankles. There is a distinct feeling of soft rolls of flesh beneath the cloth. Loosely drawn up, leaving thick loops to frame the face, the topknot is often precariously balanced on the side of the head. The faces, pear-shaped forms with delicate, hand-painted features, differ little one from another.

Several groups of figurines share a narrative content that reflects the late Tang interest in figure painting and the short story. A group of small, unglazed figurines from an undated tomb found in Hongqing village, Shaanxi, and now in the Shaanxi Provincial Museum, recreates the mood of a storyteller's performance (Fig. 3.7). A seated musician turns his upper body to the right, his head uplifted, his face bearing an expression of concentration and communion with the other players. The storyteller, seated on a stool, raises his arms in a conversational gesture, his head uplifted in speech.

Late Tang figurines are increasingly rare, yet they continued to be produced. In 1948 several figures dated to 856 were found in a tomb in Xiao Niangzi, Jiali village, in the district of Xi'an; they are now in the Shaanxi Provincial Museum. One portrays a camel and his Central Asian groom (Fig. 3.8): the foreigner extends his hands before him, holding the reins (now lost) of the camel. In response to the pressure on the reins, the camel pulls its head back. A large monster face is modelled in shallow relief on the saddle-bag. The camel is nicely realized, with textural contrasts between areas of hair and the tufts of fur on the body, but the eighth-

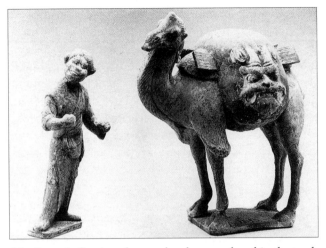

3.8 Ceramic figurine of a camel and groom, found in the tomb of Lady Pei, Jiali village, near Xi'an, now in Shaanxi Provincial Museum, dated 856.

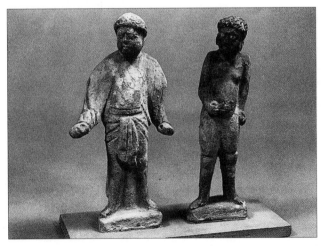

3.9 Ceramic figurines of African men, found in the tomb of Lady Pei, Jiali village, near Xi'an, now in Shaanxi Provincial Museum, dated 856.

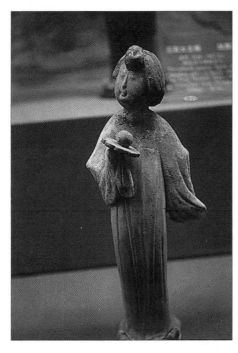

3.10 Female figure, ceramic, found in the tomb of Lady Pei, Jiali village, near Xi'an, now in Shaanxi Provincial Museum, dated 856.

century exactitude in rendering details and the overall portrait-like effect are lacking. These two pieces are not glazed, their only decoration hand-painted. Two figurines from this tomb portray foreigners from Africa (Fig. 3.9). Crudely rendered and cartoon-like, these half-naked characters are each painted black and adorned with a mass of tightly curled hair.

Lady Pei's tomb from the middle of the ninth century contained several hand-painted female figurines (Fig. 3.10). Considerably reduced in girth, these ladies of the late Tang are not yet slender, but the corpulence of the middle Tang is gone. Simply tailored garments with voluminous sleeves, their skirts taper at the feet, allowing the toes in their

upturned slippers to show. Tilting their heads, they resemble mid-Tang sculptures, but now the hairstyles, like the clothes, are subdued; a single topknot is worn at the crown. The figures hold objects in their outstretched hands: one has a petal-shaped plate with fruit, while another holds a mirror.

In addition to their great beauty, Tang ceramics provide a wealth of information about their period. The figurines, in tandem with the murals, present a paradigm for the changing ideal of feminine beauty, as well as illustrating popular pastimes of the era. Moreover, much of the brilliance of Chinese ceramic art since the Tang is built upon this dynasty's accomplishments in the development of porcelain and its successful experimentation with multi-coloured glazes.

4

Religious Art

THE TANG EMPERORS openly espoused both Daoism and Confucianism, and authorities of each religion had influence at court at various times and in differing ways. The relationship between the Li family and the Daoist authorities was a complex and often mystical one. Their affiliation began when the defeat of the Sui dynasty seemed to fulfil Daoist prophesies of the ascendance of a family named Li. Moreover, to bolster its claims of legitimacy the imperial family claimed to be descendants of the Daoist patriarch Laozi. This assumed hereditary connection established a further basis for the family's long-lasting association with the religion.

Traditionally, Daoist practices were undertaken privately. The adept often led a reclusive existence, practising life-extending arts—involving breathing, diet, exercise, and meditation—and the expression of these ideals in art. Also known were the so-called dark Daoist activities that sought to extend life by the ingestion of chemical concoctions. With Tang imperial patronage, Daoist practices were insti-tutionalized: churches were erected, anthropomorphic icons created, and formal state rituals established.

In contrast, imperial support of Confucianism was based on a frank appreciation of the practical and ethical value of the doctrine. Even before his declaration of the new dynasty, Li Yuan inaugurated the use of Confucian bureaucratic structures for legal and administrative functions. Schools for teaching Confucian curricula were established, temples to Confucius set up, and the exam system, which was based on Confucian principles, revised. In this manner, Gaozu declared Daoism and Confucianism the twin pillars

of the state. Confucians continued to dominate court politics throughout the Tang.

Daoist Art

By the eighth century, Daoism had evolved into a formal religious institution and its supremacy was established by imperial decree. Under Ming Huang, many measures were enacted to assure this new status. Daoist scholarship became a subject in the state civil exams, taking its place alongside Confucian texts. The emperor himself wrote a commentary to the primary Daoist text, the *Daotejing*, and in 740 ordered that Daoist temples be set up in all districts of Chang'an and that Daoist icons be installed in them. The next year, the temple at Laozi's birthplace was enlarged to mammoth proportions, the emperor himself presiding over the offerings. In 743, two great palaces dedicated to the Daoist thearchy were erected in Chang'an and Luoyang (Schafer, 1987: 50).

Merging his imperial identity with symbols of the Daoist church, in 744 Ming Huang declared the celebration of his birthday, the Festival of a Thousand Autumns, a national holiday and installed images of himself (as one of a trinity with Buddhist and Daoist icons) in the national temples (Benn, 1987; see also Welch, 1967: 153, 159). It seems apparent that the intent of these efforts was to supplant Buddhism, which was considered a foreign religion in spite of its great popularity, and to achieve a new unification of the country by merging Daoist cult worship and the cult of the emperor. Although other rulers, such as Wuzong (r. 840–6), followed this example in giving Daoism precedence over Buddhism, this position was never long-lasting.

Not much remains of Tang-era Daoist pictorial art, but Daoist iconic sculptures have been found from as early as

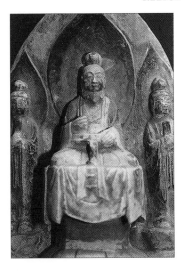

4.1 Stele with the Daoist trinity, now in Shanghai Museum, dated 740.

719. These images are greatly indebted to the Buddhist tradition, an evolution that probably began in the Six Dynasties period. As is seen in a stele dated to 740 and now in the Shanghai Museum (Fig. 4.1), the Daoist trinity with a large central figure and two smaller flanking attendants is clearly based on Buddhist images. In this example, the central deity Laojun is even seated on a lotus base in Buddhist fashion and has a halo. Of course, noticeable differences distinguish the two traditions: Daoist figures have a long and impressive beard that comes to a sharp point, and their long, silken garments are also different, although the drapery falls in a similar fashion.

Evidence of Daoist art has also been found in cave temples. Of the several unearthed in Sichuan province, the Daoist trinity with entourage in niche 11 at Anyue Xuemiaoguan (Fig. 4.2) and niche 40 at Renshou Niujiaozhai, both dated to Ming Huang's reign, are outstanding examples. Over time much Daoist art was destroyed, but its themes survive

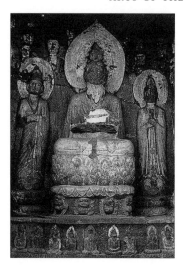

4.2 Daoist trinity, carved stone, niche 11, Anyue Xuemiaoguan, early eighth century.

on decorative objects, such as mirrors and musical instruments.

Buddhist Art

Although the emperors were guarded in their support of the Western religion, Buddhist thought and art reached their peak in China under the Tang (see Weinstein, 1987) and the era saw considerable imperial support for the construction of large-scale religious complexes. Taizong commemorated the sites of battles with temples such as Dafosi, which still stands on the outskirts of Xi'an, and in 634 built for his mother an enormous temple with ten courtyards and nearly two thousand rooms. Although Gaozong was not an enthusiastic adherent to Buddhism, he sponsored the construction of the grandiose Ximing temple, with its

thirteen halls and four thousand rooms, a section of which was recently excavated.

The greatest patron of Buddhism was no doubt the Empress Wu. Taking the precedent of the Indian Buddhist king Asoka, Wu Zetian established herself as universal ruler over the political as well as the spiritual realms. On the basis of the discovery of a scripture foretelling her reign, she was declared the living incarnation of Milo (Maitreya), the Buddha of the Future. Temples throughout the capital commemorated this occasion with the erection of large images of the Milo Buddha, the reading of scriptures, and sermons. One of the many religious institutions to enjoy her largesse was Famen temple, which housed the famous finger bone relic of the Buddha. In 660 she ordered that the relic be brought to her capital in Luoyang for worship. For the occasion, elaborate cases of gold and silver were made to contain the bone, which was carried in a procession through the streets and accompanied by all types of festivities.

By the mid-seventh century, Buddhism was an integral part of state ritual. The accession of a new emperor, birth of an imperial prince, and even ceremonies for ancestors involved chanted sutras, spells, and maigre feasts. For the celebration of Buddha's birthday and All Souls Day a great feast was held, homage was paid to Buddhist deities, sutras were recited, and sermons preached.

Tang emperors also entertained the steady traffic of Chinese and Western priests who travelled between China and India. With imperial sponsorship the scriptures were translated into Chinese, and Chinese monks went on pilgrimages to India to visit sites important in the life of the Buddha, to study in Buddhist universities such as Nalanda, and to collect scriptures and icons. During Taizong's reign the eminent monk Xuanzang returned from his journey

west with a collection of scriptures and icons. The Dayanta (Big Wild Goose Pagoda) was built in 652 by imperial order to protect the 657 volumes of Buddhist writings brought back by the monk. The seven-storey pagoda, rebuilt in the first decade of the eighth century, still stands in modern Xi'an's southern district.

The monks provided a steady flow of ideas into China and introduced new forms of Buddhism that were later adopted by the court. Because of the heterogeneous nature of Buddhist doctrine, there were many sects practising in Tang China. Early in the dynasty, the worship of Amitofu, the Buddha of Infinite Light of the Pure Land, was dominant. Entrance into his everlasting paradise was won by the mere utterance of the deity's name and visualization of his 'pure land'. Depictions of his celestial paradise and meditation practices proliferated.

The majority of the murals painted during the Tang in the Mogao grottoes, near Dunhuang, are recreations of Amitofu's paradise. The spiritual environment often takes the form of an architectural complex of jewelled towers, tiled pavilions, and stepped terraces that imitate the imperial buildings of the capital cities of central China. In cave 217 (Plate 17), for example, the enthroned Buddha of Infinite Light is seated at the centre of a palatial compound surrounded by numerous Buddhist divinities and celestials playing music. The most important part of the topography, the lotus pond in which devotees are reborn, occupies the foreground. Several newborn souls can be seen in the calyces of the lotus buds floating in the water. For the Chinese this was the first formal doctrine that had promised life in an everlasting paradise. Daoist study had rewarded a few stalwart souls the status of immortality after rather exacting practices, but this paradise was open to all.

The Hua-yan doctrine was also influential during the mid-Tang. This school considered all discrimination of the external world illusory and maintained that the universe is ruled by Vairocana, the Cosmic Buddha. It is this vision that is presented in the Fengxian temple at Longmen, near Luoyang, which was begun in 672 under Empress Wu's patronage (Plate 18). Large sculptures of the Buddha and his entourage, hewn from the living rock, were originally meant to be covered by a large wooden screen, which would allow the faithful only a partial view of the darkened interior dimly illuminated by the glow of candles and the beams of light that pierced the wooden tracery. The cave's group of nine figures is dominated by the colossal sculpture of Vairocana, whose identity is indicated in part by his unique lotus flower seat: each petal was decorated with a Buddha world, a cosmic universe replete with its own system of stars and planets, including an earth.

Stylistically, these carvings are harbingers of a new fashion based on Indian art, with its naturalistic depiction of the body, garments, and jewels. Clinging to and revealing the body beneath, the folds of the drapery are a model of classic restraint. The face of the Buddha has sensuous, bow-shaped lips, half-closed, meditative, almond-shaped eyes, and triple rings of flesh encircling the throat. A hypnotic, circular linear rhythm dominates the designs of the halo and body mandorla: an inner ring of lotus petals, a zone of seated Buddhas, and an outer area of flame patterns. These circles are reinforced by the linear design of the folds of the garment. This spiraling movement causes the viewer to concentrate on the meditative calm of the face, a still point in the midst of activity.

Flanking the Buddha are two disciples, Ananda and Kasyapa. Ananda, his youthful disciple and personal attendant, stands

4.3 Colossal Milo Buddha, carved rock, Leshan, Sichuan, *c.* 713.

on the Buddha's right, symbolizing the path to enlightenment by means of the heart. The elder Kasyapa, an eminent sage ascetic representing the path of the intellect, is on his left, the figure now damaged beyond recognition. At the sides of the group are two Bodhisattvas, deities devoted to aiding mankind in attaining enlightenment, flanked by two sets of guardian kings. Crowned Chinese generals with imperious faces, two *tianwang* stand in pronounced hip-slung poses, trampling the powers of ignorance and evil underfoot. Beside them, two muscular warrior kings are each naked but for a skirt, scarf, crown, and jewels.

Buddhist art also found support on a popular level. In addition to the commission of personal icons and the decoration of small caves and niches, several large-scale projects were sponsored locally under the direction of a guiding monk. The colossal sculpture of Milo, the Buddha of the Future, at Leshan, Sichuan, was undertaken by a local monk in 713 (Fig. 4.3). The huge, 71-metre seated

Buddha was carved out of a mountain standing at the point of confluence of three tributaries of the Yangzi. Conceived in the hope of calming the waters and thus averting the disasters caused by continual flooding of the area, the project was begun with the leadership of the monk Haitong and continued under the aegis of local magistrates, taking nearly one hundred years to complete. A similar colossal Buddha of the Future nearly 25 metres high was created between about 713 and 741 with the guidance of the monk Qu Yan and local residents at Dunhuang.

The naturalistic style is seen at the more remote caves of the Mogao grottoes. Inspired by Indian art made available by the flourishing traffic from the West, a new cosmo-politan ideal of beauty was formed. The resulting Bodhisattvas were cast as androgynous beauties, an ideal that rumours hinted was based on local singing girls (Soper, 1958: 215, n.64). In Mogao cave 45, the slim, elongated figures of the Bodhisattvas have heads that incline slightly (Plate 19). Realistic concerns are evident as well in the contrasting characterization of the disciples Ananda and Kasyapa who, no longer abstract representations of age and youth, are clearly drawn individuals. Flanking the pentad are guardian figures who stand with one leg bent, one arm raised, their heads tilted; they look down with a martial grimace of furrowed brows and snarling mouths.

The headless marble Bodhisattva discovered among the ruins of the Daming Palace in Chang'an also stands in the hip-slung pose (Fig. 4.4). The deity is naturalistically articulated: the smooth flesh of the adolescent body has a protruding belly, navel, and nipples. Even the bony structure of the knees, pushing against the diaphanous material of the skirt, is carefully rendered, as are the simple accessories that adorn the body.

4.4 Bodhisattva, marble, found in Daming Palace, Xi'an, now in Shaanxi Provincial Museum, *c.* eighth century.

The Art of Esoteric Buddhism

During the reign of Ming Huang, esoteric or tantric Buddhism was introduced into China by the Indian masters Subhakarasimpha and Vajrabodhi. The esoteric doctrine depended on secret sacred words, magic formulas, prayers, images, and rituals to impart its difficult teachings. With their penchant for exclusivity, utilization of opulent diagrams and magnificent ritual objects, and building of private temples in remote and beautiful hideaways, the esoteric sects had a natural attraction for the Tang aristocracy.

Art was of particular importance in the explication of the tantric doctrine, and images of the esoteric deities often are equipped with multiple heads and numerous appendages that symbolize their awesome divine power. In esoteric representations Guanyin, the Bodhisattva of Compassion, is often equipped with eleven heads to better hear the cries

4.5 Thousand-armed Guanyin, bas-relief, cave 64, Danlizhoushan, Sichuan province, late eighth century.

of humanity. The deity may appear thousand-eyed, thousand-armed, or a combination of both. In cave 64 at Danlizhoushan Qiongxia, in Sichuan (Fig. 4.5), a bas-relief of the thousand-armed Guanyin ascribed to the late eighth century has twenty arms carved in the round and radiating out from the figure; the remainder are carved in low relief on the halo. Members of Guanyin's vast entourage are supported on lotus flowers.

A fine example of an eleven-headed Guanyin was found in the neighborhood of Xi'an in 1963 (Fig. 4.6). The exquisite marble head has an elegant coldness despite the fleshy forms of the cheeks and heavy chin. Crisply carved, the face has a distant look, appropriate perhaps to its esoteric character. The pursed lips are not smiling, and the highly arched brows convey an unyielding expression. Rising above the wavy hair are a series of ancillary heads arranged like a crown, while at the front is a standing figure of the Buddha of Infinite Light.

4.6 Eleven-headed Guanyin, marble, found in the vicinity of Xi'an, mid-eighth century.

Late Tang Buddhist Art

Throughout the Tang period there was great resentment against the Buddhist church. Much of the antagonism derived from the tax-exempt status of the Buddhist institutions and their vast holdings of land, particularly since the exemption extended to the industries that operated on temple grounds. The size and number of Buddhist lands and endowments grew with each generation.

The Buddhist monks were also the object of suspicion. The government opposed the great numbers of unproductive members of society, who neither contributed to the state nor participated in the institutions of marriage and child-rearing. Moreover, criminals, tax offenders, and others evading social responsibilities found refuge from the law within the confines of the monasteries, and there was little to distinguish the outlaws from the devout adherents to the religion. Lastly, many of the religious practices of the

Buddhists were offensive to Chinese sensibility and defied Confucian ethics.

Restrictions were repeatedly enacted to control aspects of the administration of the Buddhist church and its populace, but Buddhism was so widespread that it was relatively unregulated for most of the dynasty. When the economy began to weaken, however, hostility provoked by the wealth and influence of the Buddhist institutions and their adherents intensified. Concerted efforts to curtail the religion's growth were begun in the early ninth century under Wenzong. Under his successor, Wuzong, the government tried to extirpate Buddhism. By imperial order over four thousand monasteries and tens of thousands of private shrines were dismantled, hundreds of thousands of monks and nuns were sent back to the laity, some were said to have been slaughtered, and thousands of metal icons were melted down.

These measures were accompanied by a general xenophobic rage directed against other foreign religions, such as Nestorian Christianity, Zoroastrianism, and Islam. With similar zeal, Wuzong elevated the Daoist church. Soon after his death, however, there was a large-scale restoration of Buddhism and its monuments. Gradually temples were reopened, both in the capital and the provinces, although Chinese Buddhism never truly recovered from the destructive rage of the mid-ninth century.

At the important religious site of Wutaishan, in Shanxi province, five temples were restored after the destruction of Wuzong's reign. Foguansi, the Temple of the Buddha of Light located at the foot of the slopes, was rebuilt in 857. Organization of its main altar, with five groups of deities and their entourages, suggests the geographical structure of Wutaishan and its five terraces.

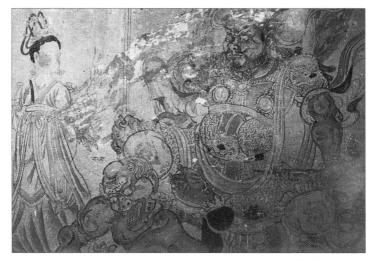

4.7 Guardian and female figure, mural, Great Eastern Hall, Wutaishan, Shanxi province, 857.

The drawing in the murals of the Great Eastern Hall is particularly brilliant: in one mural a corpulent, burly guardian general sits cross-legged while pinning two naked grotesque demons under his knees (Fig. 4.7). Superb drawing renders his extraordinary musculature, awesome facial expression, and energetically fluttering scarves. In contrast to this paragon of masculine strength is the demure and delicate maiden standing to the side. Dressed in a red and aqua costume of a long-sleeved silken garment and apron, she has two elegant braids arrayed with flowers on top of her head. Beside her a demonic figure, naked but for a leopard-skin loincloth, has fangs and glowing aqua eyes (Fig. 4.8). Sepia ink was used to render the parts of his body, while shading captures his muscular strength. Behind him is a skeletal creature, his anatomy drawn in tones of red. The exaggerated realism and emotional content of these images are the hallmarks of late Tang art.

Restoration activities continued under Yizong, whose reign provided one of the best-known Tang documents: the earliest extant printed piece of paper in China, a Buddhist text found in the library of Mogao cave 17. From this evidence, it can be said that the woodblock technique for printing was in use long before the scroll of the Diamond Sutra, dated 868, was printed. Yizong is now remembered for his lavish patronage of Famen temple, as a number of fabulous objects excavated from its basement bear imperial inscriptions dated to his reign. The temple's finger bone relic of the Buddha was hidden in a secret niche in a series of boxes (Fig. 4.9): the innermost jade, while the others included ones of crystal and sandalwood, a gilt silver casket with an inscription, and an outer iron box.

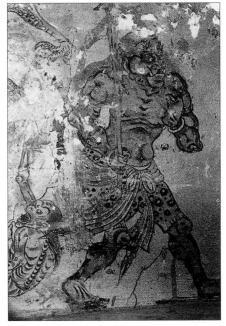

4.8 Demon, mural, Great Eastern Hall, Wutaishan, Shanxi province, 857.

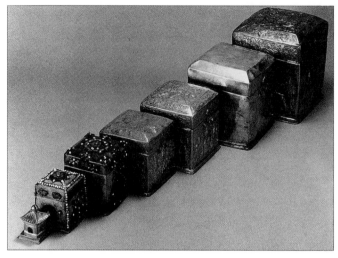

4.9 Relic boxes, Famen temple, near Xi'an, 874–88.

The temple also holds a delicate and refined sculpture of a kneeling Bodhisattva (Plate 20), who holds in his outstretched hands a tablet with a sixty-five character inscription dated to 873. The inscription states that the sculpture was made as a birthday gift for Yizong and declares the emperor's intention to move the bone relic. The kneeling deity is made of silver, with gilt accents for his jewelry and clothes, and south sea pearls adorn his neck and crown. Displayed on the statue's silver hourglass-shaped base are the new icons of the esoteric sect (Plate 21). In addition to the celestial musicians on the top are four guardian kings in the middle and eight esoteric deities with multiple hands, weapons, and a large mandorla of flames.

Emperor Xizong's lavish gifts to the Famen temple are recorded and dated to 874. In 888, at the end of Xizong's reign, the temple's underground rooms were closed. The

articles given by the emperor were clearly associated with esoteric rituals. Sets of plates were made for offerings, while incense burners, bowls, utensils, and priests' garb including vestments, bracelets, a ceremonial staff and a sceptre are all part of the collection. As the magnificent treasures of Famen temple demonstrate, Buddhism enjoyed imperial patronage in the late Tang. The treasures of Famen attest to the continued prominence of certain Buddhist temples after the great persecution, as well as the highly skilled production of works of art in the late Tang.

The burning of the scriptures during Wuzong's 845 suppression of the religion clearly took its toll on the schools of Buddhist thought that were dependent on texts and their exegeses [Weinstein, 1987]. Those beliefs which were dependent neither on the monastic life nor on scriptural traditions, however, such as the Cult of the Western Paradise and the Chan (Zen) sect, flourished. The meditative Chan school prided itself on the importance of self-realization without the aid of rituals, icons, or scriptures. Later Chan icons accordingly show patriarchs burning wooden sculptures of the Buddha for warmth or tearing up the Buddhist scriptures.

5

Funerary Art

THE LARGE TOMBS erected for the Tang emperors reflect the social conditions prevailing at the time they were built. The early tombs, impressive both in scale and complexity, demonstrate the power and authority of the imperial government. Those of the later emperors mirror the growing dissolution of the dynasty's strength. With the final rapid succession of short-lived reigns, little effort was expended to build funeral monuments.

The practice of erecting a large imperial tomb was eschewed by the first Tang emperor, Gaozu. True to the Confucian doctrine of modesty, he refused to construct one, insisting that his burial be frugal (see Wechsler, 1985: 149ff.). After Gaozu's death his son and successor disregarded his wishes, in 635 enlisting the famous artist Yen Lide to build a monument to the founder of the dynasty. The tomb, 60 kilometres north-east of the capital, is surrounded by a square wall, with four towers at the corners and gates on its four sides. Marked by a large earthen mound, the tomb of Gaozu has not been excavated. Of the original four stone tigers that stood each inside one of the four gates, one remains (Fig. 5.1). A second tiger and a rhinoceros from the tomb path are now housed in the Shaanxi Provincial Museum. Both animals are noted for their fierceness and independence: majestic creatures, they are symbolic of the strength and pride of the emperor.

In contrast to his father, Taizong was deeply involved in the planning of his funeral monument, and the structure clearly demonstrates his personal choices. For the first time an imperial tomb was set into a mountain, allowing greater monumentality and longevity. The imperial tomb at Zhaoling,

5.1 Stone tiger from the tomb of the emperor Gaozu, outskirts of Xi'an .

north-west of Xi'an, was the centre of a walled city around which the emperor's closest followers were allowed satellite tombs laid out along broad avenues. There were three underground chambers; the above-ground offering hall, shrine, and altar have not survived. The processional *shendao* was marked by life-size, free-standing stone carvings of animals and men, including fourteen representations of barbarian chiefs vanquished by Taizong, only the bases of a few of which remain. Not much is left of the *shendao*: a standing horse is the only sculpture that still stands at the site.

The six bas-relief portraits of the chargers that served Taizong in his military campaigns, once displayed by the entrance to his tomb, are still intact. The sensitive and naturalistic portrayals of the six chargers (see Fig. 1.9) contrast greatly with the clumsy representation of the *shendao* horse. This difference is in part due to the low

esteem in which large-scale stone sculpture was held in China, while bas-relief carving was an ancient art tied to the preservation of edicts, literary epigraphs, and calligraphy.

Qianling, Gaozong's tomb, is also set in a mountain and was enclosed by a wall with four gates guarded by stone lions. Inside the entrance are sculptural figures of foreign ambassadors arranged in two groups. Twenty-nine on one side, thirty-one on the other, their heads are all missing. The spirit way is relatively well preserved: pairs of sculptured columns, winged horses, paired ostriches, five pairs of saddled horses each with a groom, their heads removed by vandals (Plate 22), ten pairs of officials (twice life-size), two great stone dragon-topped steles 6 metres high, and two brick pylons are still *in situ*.

A Qianling sculpture of a Chinese official stands rigidly, the modelling of his facial features, although suggestive of a portrait, hard-edged and unconvincing (Fig. 5.2). The drapery falls close to the body, but it does not reveal the form beneath, and the shallow carving does not suggest actual material. At the same site, two bas-relief profile carvings of ostriches standing alert, heads held high and tails raised, are relatively naturalistic. As the bird is not native, they must have been based on creatures sent as foreign tribute (Schafer, 1962: 102). The free-standing animal sculptures are relatively static, their shape limited to the dimensions of each rectangular block of stone. Prudently, the artist did not remove the area between the legs of a winged lion but camouflaged it with a shallow carving of clouds.

Ming Huang's tomb, Tailing, located on Mount Jinsu north-east of Xi'an, conforms to the imperial standard, with the addition of eight standing figures on the *shendao*. Many of the original sculptures of the *shendao* are in place: six of the eight lions placed at the four gates, one broken

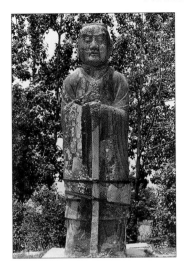

5.2 Chinese official, Qianling mausoleum, near Xi'an, late seventh century.

column, both flying horses, and two peacocks have survived, in addition to nine pairs of men and eleven of the sixteen horses. Like the art produced at Ming Huang's court, these sculptures display an unprecedented degree of naturalism. Although the figure of a winged horse still predominantly follows the shape of a squarish block of stone, and the stone in the area beneath its legs has been retained for structural purposes (disguised as cloud swirls), the head is a fine portrait of a noble, gentle steed. The mane falls in natural locks and, unlike in earlier treatments of the subject, the wings are thick bands of feathers terminating in swirls.

By the time of Suzong's interment in 762, an even more dramatic change had taken place in the depiction of the officials (Fig. 5.3). The modelling of the facial features is truly subtle: a fleshy pear-shaped face has gentle rounded cheeks swelling at either side of the mouth; the bony structure supporting the thick flesh is indicated in the brow. The eyes are rendered in precise detail, the eyeball deeply

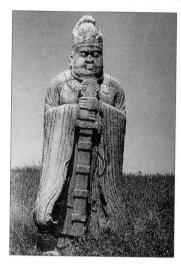

5.3 Stone guardian from the tomb of the emperor Suzong, near Xi'an, mid-eighth century.

carved, the skin of the eyelid stretched over the protruding eyeball. Both the slightly raised eyebrow and the faintly turned-down mouth convey a stern, discerning expression. As is seen in its counterparts in the tomb murals and figurines, this is a true portrait of an individual character.

Although emperors after Ming Huang enjoyed tombs nearly as splendid as his, the workmanship gradually degenerated. Dezong's *shendao*, at Chongling in the Cuo'e Mountains, shares the same number and arrangement of figures as does Xuanzong's spirit way. All of the lions are extant, as are the columns, ostriches, flying horses, and one standing figure, but the official and horse sculptures are severely damaged. Although not substantially reduced in size, these sculptures demonstrate a decrease of monumentality: one of the winged horses stands nobly, but his head is disproportionately small and the features shallowly carved, barely projecting beyond the surface. The carving of the ostrich is much smaller in size and simpler in

execution, its parts unconvincingly modelled. At Wuzong's tomb, said to have been created in the typical Tang mode, three of six stone horses, one column, six of the flying horses, and five officials are reported as broken and lying down. A recent visit to the site evinced only two lions, both poorly carved and small in stature (Fig. 5.4).

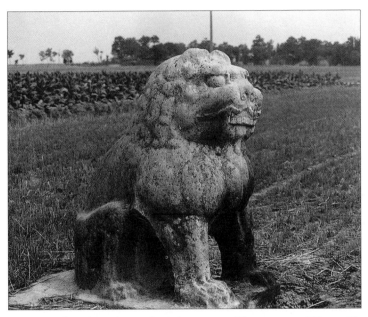

5.4 Stone lion from the tomb of the emperor Wuzong, near Xi'an, mid-ninth century.

Chronological Table of the Tang Dynasty

Gaozu reign	AD 618–626
Taizong reign	627–649
Gaozong reign	649–683
Empress Wu Zetian's reign	684–705
Zhongzong reign	705–710
Ruizong reign	710–712
Xuanzong reign	712–756
Suzong reign	756–762
Daizong reign	762–779
Dezong reign	779–805
Xunzong reign	805
Xianzong reign	805–820
Muzong reign	820–824
Qingzong reign	824–826
Wenzong reign	826–840
Wuzong reign	840–846
Dazong reign	846–859
Yizong reign	859–873
Xizong reign	873–888
Zhao Zong reign	888–904
Zhao Xuan Di reign	904–907

Selected Bibliography

Acker, William, trans. (1954), '*Lidai Minghuaji*', in William
 Acker, *Some T'ang and Pre-T'ang Texts on Chinese
 Painting*, Leiden: E. J. Brill.
Benn, Charles (1987), 'Religious Aspects of Hsuan Tsung's
 Taoist Ideology', in David W. Chappell, ed., *Buddhist
 and Taoist Practice in Medieval Chinese Society*,
 Honolulu: University of Hawaii Press.
Cambridge History of China (1979), 'Sui–Tang', vol. 3,
 Cambridge: Cambridge University Press.
Fontein, Jan, and Wu Tung (1976), *Han and Tang Murals*,
 Boston: Museum of Fine Arts.
Graham, A. C. (1965), *Poems of the Late Tang*,
 Harmondsworth: Penguin Books.
Hayashi, Ryoichi (1975), *The Silk Road and the Shoso-in*,
 New York: Weatherhill.
Li Zhi-yan (1972), 'Tangdai Ciyao Gaikuang yu Tangci de
 Fenqi', *Wenwu*, 3: 34–48.
Mahler, Jane Gaston (1959), *Westerners Among the Figurines
 of the T'ang Dynasty of China*, Rome: Istituto Italiano
 per il Medio ed Estremo Oriente.
Medley, Margaret (1981), *T'ang Pottery and Porcelain*,
 London: Faber.
Schafer, Edward (1962), *The Golden Peaches of Samarkand:
 A Study of T'ang Exotics*, Berkeley: University of
 California Press.
Schafer, Edward (1987), 'The Dance of the Purple Culmen',
 T'ang Studies, 5: 50.
Soper, Alexander, trans. (1951), *Experiences in Painting (T'u
 Hua Chien-wen Chih)[Tu Hua Jianwen Zhi]*, Washington,
 DC: American Council of Learned Societies.
Soper, Alexander, trans. (1958), 'T'ang Ch'ao ming hua lu

[Tang Chao Ming Hua Lu] of the T'ang Dynasty by Chu Ching-hsuan of the T'ang', *Artibus Asiae*, 21: 205ff.

Soper, Alexander, trans. (1960), 'A Vacation Glimpse of the T'ang Temples of Ch'ang-an' *[Sidaji]*, *Artibus Asiae*, 23: 15–38.

Waley, Arthur (1952), *The Real Tripitaka*, London: Allen and Unwin.

Wechsler, Howard (1985), *Offerings of Jade and Silk: Ritual and Symbol in the Legitimation of the T'ang Dynasty*, New Haven: Yale University Press.

Weinstein, Stanley (1987), *Buddhism under the Tang*, New York: Cambridge University Press.

Welch, Holmes (1967), *Taoism: The Parting of the Way*, Boston: Beacon Press.

Wright, Arthur F., and Twitchett, Denis, eds. (1973), *Perspectives on the T'ang*, New Haven: Yale University Press.

Index

MAP OF CHINA